SUNDERLAND
IN
50
BUILDINGS

MICHAEL JOHNSON

AMBERLEY

First published 2016

Amberley Publishing, The Hill, Stroud
Gloucestershire GL5 4EP

www.amberley-books.com

British Library Cataloguing in Publication Data.
A catalogue record for this book is available from the British Library.

ISBN 978 1 4456 5117 0 (print)
ISBN 978 1 4456 5118 7 (ebook)

Origination by Amberley Publishing.
Printed in Great Britain.

Contents

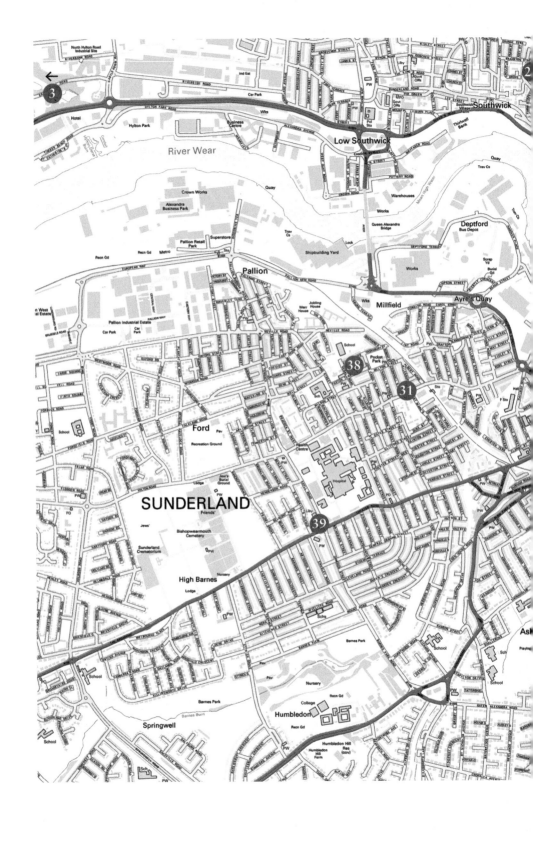

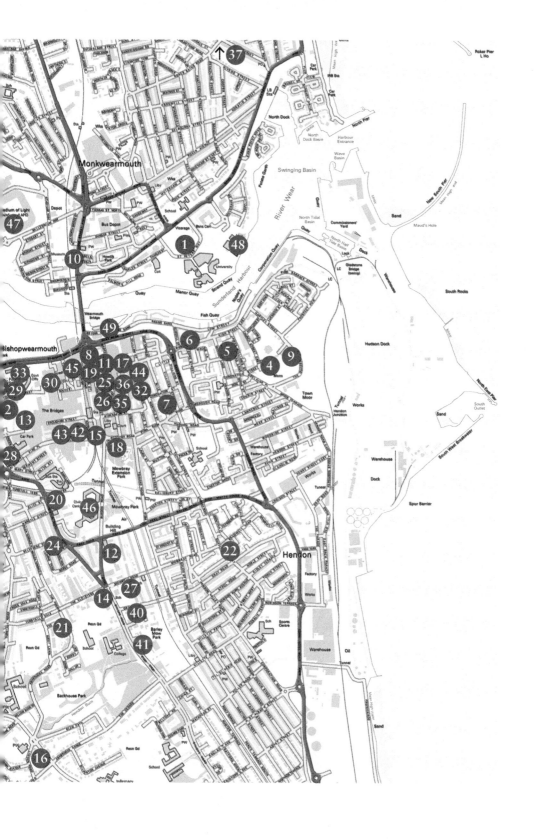

Key

1. St Peter's Church
2. Sunderland Minster
3. Hylton Castle
4. Holy Trinity Church
5. Queen Street Masonic Hall
6. Sunderland Exchange
7. St George's Chapel
8. St Mary's RC Church
9. Trafalgar Square
10. Monkwearmouth Station
11. Hutchinson's Buildings
12. Bede Tower
13. Mowbray Almshouses
14. Christ Church
15. Gas Company Offices
16. Ashbrooke Tower
17. Sunderland Museum, Library and Art Gallery
18. National Provincial Bank
19. Elephant Tea Rooms
20. Grange Chapel
21. St John's Church, Ashbrooke
22. St Ignatius' Church, Hendon
23. St Columba's Church, Southwick
24. St George's Presbyterian Church
25. Corder House
26. Sydenham House
27. Langham Tower
28. Technical College
29. Dun Cow
30. Londonderry Arms
31. Mountain Daisy
32. Sunniside Chambers
33. Police Station and Magistrates' Court
34. Empire Theatre
35. Hawksley House
36. River Wear Commissioners' Building
37. St Andrew's Church, Roker
38. St Joseph's RC Church, Millfield
39. St Gabriel's Church
40. Hammerton Hall
41. Sunderland Synagogue
42. Regal Cinema
43. Ritz Cinema
44. Joplings Store
45. Astral, Planet and Solar Houses
46. Sunderland Civic Centre
47. Stadium of Light
48. National Glass Centre
49. Echo 24
50. CitySpace

Introduction

From its origins as one of the foremost centres of learning in Christendom to its industrial triumph as the 'largest shipbuilding town in the world', Sunderland has a rich and varied history. This extraordinary story is embodied in the buildings that have survived amid the changing townscape. From the Saxon church of St Peter to the modern Stadium of Light, this book explores the history of Sunderland by analysing fifty of its greatest architectural treasures.

The buildings chosen for inclusion represent the best of Sunderland's architectural heritage, as well as notable curiosities and structures that were essential to the city's development. The churches, banks, theatres, pubs and cinemas of Sunderland's industrial heyday are examined alongside the innovative buildings of a twenty-first-century city. The entries are arranged chronologically to tell the story of Sunderland's development through its most significant buildings and a specially designed map appears at the beginning of the volume to show where each structure is located.

The city of Sunderland developed from three smaller settlements clustered around the mouth of the River Wear. The oldest was Monkwearmouth, a monastic settlement on the north bank of the Wear, dominated by the Saxon church of St Peter. South of the river was the medieval parish of Bishopwearmouth. To the east lay the 'sundered land', so called because it was divided from the lands of the Wearmouth monks by the river. This area was designated as Sunderland parish in 1719, and the township began to spread westwards. The construction of Wearmouth Bridge in 1796 joined these areas with Monkwearmouth to the north. From this point on, Sunderland was increasingly recognised as a single town, and the three parishes were officially incorporated into Sunderland Borough in 1835.

By this date, Sunderland had developed into a major industrial centre. Shipyards, collieries, potteries, iron foundries and glassworks proliferated throughout the town. Wearmouth Colliery, at one time the deepest coalmine in the world, began producing coal in 1835, and the building of railways and docks allowed ever greater quantities to be transported. Ancillary trades developed in response to this burgeoning industry. A notable success was James Hartley's glassworks, which was producing a third of all plate glass made in Britain by 1850.

Sunderland's greatest industry was shipbuilding, which was already well established by 1717 when the River Wear Commission was founded. The commissioners dredged the river and developed its infrastructure. According to Lloyd's *Register of Shipping* in 1834, Sunderland was 'the most important shipbuilding centre in the country, nearly equalling, as regards number and tonnage of ships built, all the other ports put together.'[1] Shipbuilding was key to the town's identity and a major source of pride to workers and their families.

Expressing this evolution, Sunderland's architecture largely conforms to national patterns in terms of styles, building materials and construction methods. However, the city exhibits many achievements and local curiosities that are worthy of note. The most

pressing factor in Sunderland's development was the need to provide accommodation for the increasing population. The middle classes moved to elegant neoclassical terraces on the Fawcett estate until commercial development undermined its exclusivity. Thereafter, they built distinguished villas and Italianate terraces on the Mowbray estate and in the leafy suburb of Ashbrooke.

Industrial growth demanded facilities for capital organisation. Palatial banks were erected on Fawcett Street, which emerged as the town's major financial axis. Some of these were designed by important national practitioners and introduced the latest architectural styles to Sunderland. Commercial enterprise also provided places of entertainment and leisure, including theatres and public houses. Vital public services were provided by public or charitable bodies, while utilities like water and gas were provided by commercial firms. All of these enterprises imbued the town with sophisticated buildings in a range of fashionable styles.

The expanding urban community needed churches and chapels in which to worship and many of Sunderland's finest buildings lie within the field of ecclesiastical architecture. Holy Trinity is a well-preserved example of a Georgian church, boasting a baroque reredos and fine contemporary detail. Christ Church and St John's, Ashbrooke represent the zenith of Sunderland's achievements in Gothic architecture, while St Andrew's at Roker is a masterpiece of the Arts and Crafts movement.

A century of steady development culminated in the Edwardian period, when Sunderland was crowned with public and commercial buildings in the baroque style, sometimes revealing the influence of continental art nouveau. Law courts, offices, theatres and public houses were designed in the vigorous Edwardian baroque manner as an expression of civic pride. In retrospect, 1907 was an *annus mirabilis* for Sunderland architecture, with the completion of St Andrew's Church, the Empire Theatre and the graceful offices of the River Wear Commissioners.

After the Second World War, Sunderland experienced a period of decline that saw the closure of traditional industries. The central shopping area was completely remodelled and older housing was replaced by modern council estates and tower blocks. Sunderland won city status in 1992 and its subsequent development has been powered by efforts to envisage a new post-industrial future. The turn of the millennium has witnessed a programme of regeneration, as ambitious projects and high-tech industries have transformed derelict industrial sites into exciting new ventures. Amid all of this change, it is important to acknowledge Sunderland's architectural heritage and to cherish the buildings that embody its vibrant history.

The 50 Buildings

1. St Peter's Church

St Peter's Church, in the ancient parish of Monkwearmouth, is one of the foundation stones of English ecclesiastical architecture. This Saxon treasure, one of the first stone churches in Britain, was built as part of the twin monastery of Monkwearmouth-Jarrow and became the most important centre of learning in the north of England, producing the greatest Anglo-Saxon scholar, Bede (*c.* AD 672–735).

The monastery was founded by Northumbrian noble Benedict Biscop (*c.* AD 628–690) in AD 673 on land granted by King Ecgrith. Benedict's ambition was, according to Bede, '*lapideam sibi ecclesiam iuxta romanorum quem semper amabat morem*' – 'to build him a church of stone, according to the custom of the Romans, which he had always admired.'[1] Following a further grant of land in AD 682, Benedict erected a sister monastery at Jarrow, with a church dedicated to St Paul.

To build the churches, Benedict brought stonemasons and glaziers from Gaul on the recommendation of his friend, Abbot Torhthelm. These were among the first ecclesiastical structures in Britain to be built of stone and contained some of the first window glass in the country. The monastery housed a library that Benedict had collected on his travels.

Figure 1. The Saxon church of St Peter.

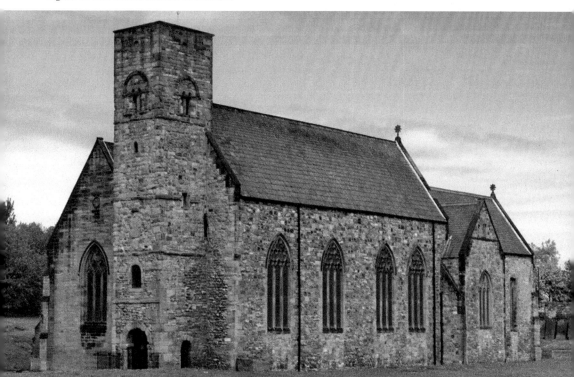

Under the leadership of Ceolfrith (*c.* AD 642–716), the monastery at Jarrow developed into a distinguished centre of learning and book production. The Venerable Bede received his education under Ceolfrith and established himself as England's leading scriptural and historical scholar. The scriptorium produced Bibles to furnish the churches of St Peter's and St Paul's, and a third that was intended as a gift to Pope Gregory II. The only survivor of these volumes is the copy that Ceolfrith himself was carrying to Rome when he died in AD 716. Now in Florence and known as the *Codex Amiatinus*, this beautifully illuminated volume is the oldest Vulgate Bible in the world.

Commenced in AD 674, St Peter's Church survives as a monument to Benedict Biscop's glorious vision. The only traces of the original church are the lowest stage of the tower and the west wall of the nave. It is likely that the nave followed roughly the same layout as the present church. A porch was built at the west end between AD 674 and AD 686 and this forms the base of the present tower. A second storey was added to the porch around AD 700, together with a flanking porticus that has since been removed. Vivid Saxon artwork is still visible on the weathered stones. Inside the archway are mythical creatures with interwoven tails and elongated jaws. A decorative frieze with animals has been identified on the west face of the tower and an eroded sculpture of a haloed figure, possibly St Peter, occupies the gable end. The tower was built up to its current height at the end of the tenth century, complete with the present belfry windows.

The church has undergone extensive rebuilding throughout its history. A north aisle was added in the thirteenth century and a large east window followed in the fourteenth. The monastic buildings to the south were replaced *c.* 1074–83 under Prior Aldwin, but the principal structure was a long gallery leading to an unidentified building to the south. The monastery was dissolved by Henry VIII in 1536. The remains of the monastery were incorporated into a private mansion, but this was burned down in 1790, and no trace of the original monastic buildings is now visible.

By the nineteenth century, the church was scarred by the ravages of time and deteriorating rapidly. Interest in the Saxon tower and concern for its preservation were growing among Victorian antiquarians and in 1866 the Newcastle architect Robert James Johnson (1832–92) was asked to examine the condition of the church. His report was published in *The Ecclesiologist*, the leading journal for those interested in church-building and restoration. The crumbling structure was in need of restoration and, in 1875–76, it was extensively remodelled by Johnson at a cost of £7,190.

Johnson was the best architect of his generation in the North East, with a supreme command of classical, Gothic and Renaissance styles. He was so pious that he was said to pray over his designs and, as a committed antiquarian, he was generally sensitive in his approach to restoration. His work at St Peter's involved the conservation of the Saxon remains and the building of virtually a complete new church for the use of parishioners.[2] Johnson rebuilt the north aisle and extended it east, pushed the south wall out onto older foundations and reproduced the east window.

The church has retained precious sculptural monuments, including a splendid grave cover with recumbent figure (*c.* AD 700), a defaced effigy of a priest (fourteenth century) and another of a knight (fifteenth century). Modern additions to the building include an octagonal 'chapter house' serving as a café and visitor centre (1973). The layout of the original monastery is now replicated by low stone walls and landscaping that was completed in 2015.

2. Sunderland Minster

Sunderland Minster was built as the parish church of Bishopwearmouth and dedicated to St Michael. The church crowns the crest of a rocky knoll, which is all that survives of Bishopwearmouth Green. The present structure is the result of centuries of rebuilding. A church dedicated to St Michael has stood on this site for over a thousand years. The parish was founded around AD 940 and given the name Bishop's Weremouth to distinguish it from its venerable neighbour at Monk's Weremouth. A stone church may have been built shortly afterwards, as evidenced by Saxon stones that were found during a 1930s excavation.

A substantial stone church was built in the thirteenth century and remnants of it survive in the present structure. In 1704, the church was restored by Rector John Smith and the medieval chancel was largely reconstructed. The Georgian and Victorian periods brought further alterations according to the religious and aesthetic precepts of the time. The tower was built in 1807 and is Gothick in style, ending with battlemented parapets. The transepts were added in 1849–50 by the eminent Newcastle architect John Dobson (1787–1865) in the decorated Gothic style of *c.* 1250–1350.

Due to colliery subsidence, the church was virtually rebuilt between 1933 and 1935. This work was conducted in a conservative neo-Gothic manner by W. D. Caröe (1857–1938) on a scale rarely seen in the twentieth century. The restorations were funded by Sunderland's greatest philanthropist Sir John Priestman (1855–1941) at a cost of £35,000. The result is a beautifully proportioned church by a late master of the Gothic Revival.

Inside, the short nave is divided by elliptical-headed arches springing from polygonal piers. The nave was rebuilt with double aisles to increase its capacity. Excellent woodwork was introduced, including galleries in the transepts, an organ case and a pulpit with sounding board. Surviving treasures include a seventeenth-century font on a pedestal decorated with acanthus leaves, as well as medieval grave-covers and an eroded effigy, said to be that of Thomas Middleton of Silksworth.

Figure 2. Sunderland Minster.

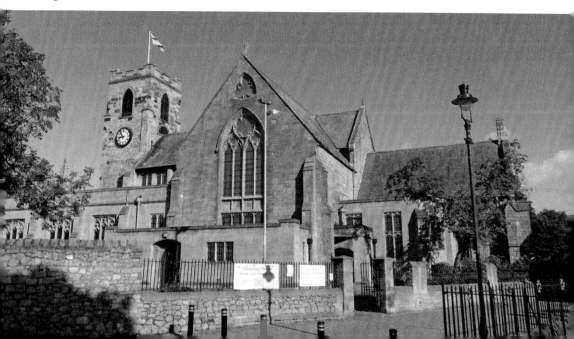

Glass partitions were inserted into the outer aisles in 1981 by church specialist Ian Curry to form a community centre. In 1998, following the grant of city status to Sunderland, the church was designated as Sunderland Minster, making it probably the first minster church established in England since the Reformation. Arts and Crafts glass by Morris, Marshall, Faulkner & Co. was transferred here from Christ Church in 2000. The resplendent biblical scenes were designed by William Morris (1834–96) himself and the Pre-Raphaelite painters Burne-Jones, Rossetti and Ford Madox Brown.

3. Hylton Castle

Hylton Castle is the ruin of a fortified gatehouse on the north bank of the River Wear. This medieval landmark was built as a residence and showpiece for the powerful Hylton family, who owned land across Northumberland, Durham and Yorkshire. The history of the castle dates from the Norman Conquest, when William the Conqueror granted Henry de Hilton a large tract of land north of the Wear in gratitude for joining the king's forces. The first castle on the site was built by Henry *c.* 1072 and was probably constructed of wood.

The present castle was built by Sir William de Hylton (1376–1435) in the late fourteenth century and was complete by 1410. Described as a 'gatehouse constructed of stone', it exemplified a particular type of small fourteenth-century castle, similar to Old Wardour in Wiltshire. The impressive gatehouse tower was a compact rectangular block providing living accommodation for the Hylton family. In the surrounding grounds stood a hall, chapel and kitchen, possibly arranged around a courtyard.

Figure 3. The powerful gatehouse of Hylton Castle.

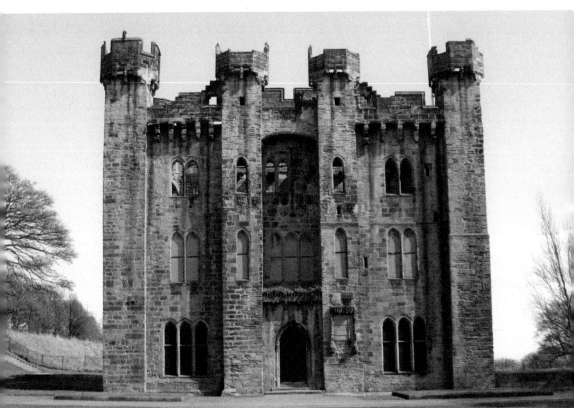

The subsequent history of the castle is a tapestry of expansion, alteration and neglect. Early in the eighteenth century, John Hylton (d. 1712) inserted Italianate pedimented windows and built a three-storey north wing, as seen in Bucks' engraving of 1728. A south wing had been added by 1746, and the castle effectively became the centrepiece of a Georgian country house. Stucco decorations were provided by Italian master Pietro La Francini, who frequently worked with Daniel Garrett (d. 1753), and it was probably Garrett who added a Gothick porch and screen, similar in style to his frivolous banqueting house at Gibside. William Howitt's *Visits to Remarkable Places* (1842) notes that the rooms had 'stuccoed ceilings, with figures, busts on the walls and one large scene which seems to be Venus and Cupid, Apollo fiddling to the gods, Minerva in her helmet and an old king.'[3]

In 1746, the castle was purchased by Lady Bowes, the widow of Sir George Bowes of Gibside, but she never lived in it. The building was sold to William Briggs, a local timber merchant and shipbuilder, in 1869. Following the Victorian passion for medievalism, Briggs remodelled the exterior to give it a more authentic medieval appearance, demolishing the eighteenth-century wings and substituting a dignified Gothic arch for the porch.

Despite all these changes, what we see today is essentially the shell of William de Hylton's castle. The imposing west front is braced by four square towers, each topped with machicolated octagonal turrets. Five stone defenders stand on the battlements to create the illusion that the castle was manned by soldiers. The same tactic was used at Alnwick and Raby castles. Above the entrance is a proud display of heraldry, featuring the arms of the king, the Hyltons and other noble dynasties. One of the shields bears the 'stars and stripes' of the Washington family, who trace their ancestry to the region. Between the central towers once stood a sculpture of a knight vanquishing a serpent, perhaps inspired by the local legend of the Lambton Worm.

Figure 4. Samuel and Nathaniel Buck's engraving of Hylton Castle (1728).

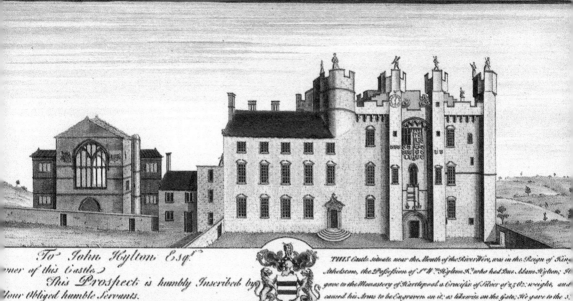

THE WEST VIEW OF HYLTON-CASTLE, IN THE BISHOPRICK OF DURHAM.

The rear elevation is dominated by a broad square tower incorporating a spiral staircase. High-quality carving depicts the crest of William de Hylton and the white hart of Richard II. Some charming eighteenth-century features survive, including the Gothick screen.

The ruin of St Catherine's Chapel stands within the castle grounds and retains a large east window in the Perpendicular Gothic style, which flourished *c.* 1350–1550. The west end of the chapel dates from the eighteenth century, when the chancel arch was filled in. Hylton Castle passed into the hands of the Wearmouth Coal Company *c.* 1908 and was taken over by the State in 1950. Today, the castle is owned by English Heritage and is due to undergo a £4 million conversion into a heritage centre. One of Sunderland's few medieval buildings, it is an architectural treasure of great historical significance.

4. Holy Trinity Church

As the port of Sunderland began to prosper, local residents petitioned for a church of their own, complaining that the walk to Bishopwearmouth church was nearly a mile uphill. This area was designated as Sunderland parish in 1719 and a church was built in the same year to serve the soaring population of the East End.

Holy Trinity Church is one of Sunderland's Georgian treasures, exemplifying the graceful architecture for which the period is renowned. The design is beautifully simple, with a rectangular plan and symmetrical frontage. Designed in the baroque style, a derivative of classical architecture, it has harmonious proportions, and the use of brick defined it as a modern building for the Age of Enlightenment, in contrast to the stone churches of the Middle Ages.

The design is attributed to William Etty of York (*c.* 1675–1734), a carpenter and architect who had worked with the esteemed architects Colen Campbell (1676–1729) and Sir John Vanbrugh (*c.* 1664–1726).[4] He later designed a church with the same name in Leeds (1722–27), which was very similar in plan, though grander in execution, and this supports the theory that he was responsible for the Sunderland church.

A stately tower rises at the end of the nave without disrupting the rectangular floorplan. Contemporary images reveal that the tower was originally crowned with a cupola, but this was removed in 1738. The frontage is articulated with sandstone dressings to impart a sense of architectural dignity and the main entrance is set within a rusticated baroque arch (i.e. the stonework is exaggerated to convey an impression of strength).

Located beneath the tower, the entrance porch is dominated by a statue of Robert Gray (1787–1838), a testament to the great esteem in which this former rector was held by his parishioners. Made of Cararra marble, the statue was sculpted by David Dunbar (*c.* 1793–1866) of Carlisle in 1838, and stands upon a monumental plinth. Gray's outstanding virtues are celebrated in allegorical representations of Faith and Charity, both represented by relief sculptures of women nurturing children.

Beyond the porch is a broad narthex or antechapel, containing a robust font for baptisms. The fluted bowl is surmounted by a glorious canopy of urns, cherubs and scrolled forms, which can be hoisted away when baptisms are in progress. The cable for this mechanism is fed into a tiny dome in the ceiling, and the dome's inner surface is painted with winged cherubs cavorting in the sky.

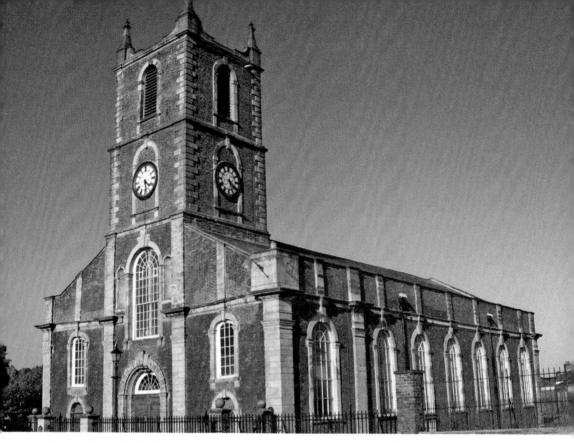

Figure 5. Holy Trinity Church represents the origins of modern Sunderland.

The spacious nave is a vision of Georgian grace: the simple rectangular space is divided by elegant Corinthian columns and flooded with light from clear glass windows. Holy Trinity was intended as an auditory church, where the congregation would listen to a charismatic preacher, in contrast to the ritual churches that were built to follow Catholic liturgy. The pulpit occupied the focal point and the abiding impression is of clarity and order.

At the west end is a gallery supported on slender columns of extremely fine workmanship.[5] It was here that the church declared its political loyalties: a splendid representation of the arms of George I showed the parish's allegiance to the Hanoverian succession that put him on the English throne. Stalls beneath the gallery are labelled with the titles of the officials involved in administering the parish.

At the east end, a low communion rail extends across the breadth of the church. A charming feature is the bow-shaped gate that swings open to allow access to the altar. The interior culminates in a stunning baroque arch framing the chancel. This is an elaborate design reminiscent of the work of Nicholas Hawksmoor (c. 1661–1736). Paired columns support a round arch with winged cherubs beaming down from its summit. Towering above are three broken pediments enclosing sculpted symbols – bishops' mitres and an open Bible. Through the chancel arch is a circular apse that was added by Rector Daniel Newcome in 1735. The tripartite Venetian window was filled with stained glass by James Hartley & Co. in the Victorian period.

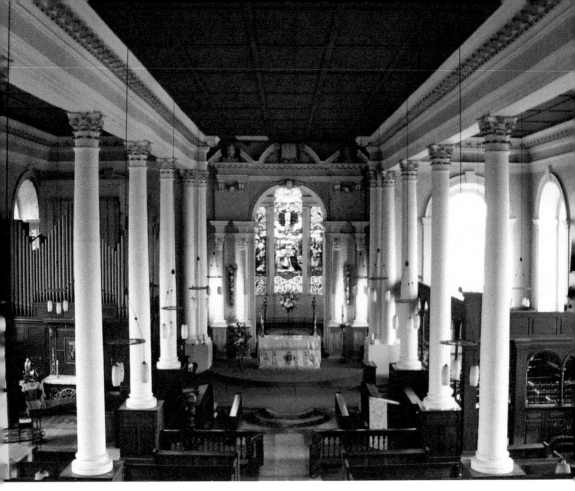

Figure 6. The spacious nave and baroque chancel arch.

Holy Trinity Church demonstrates that baroque influence had filtered into provincial architecture by this date. The baroque style emerged in Rome *c.* 1600 and was initially used to reassert the authority of the Catholic Church during the Counter-Reformation. Its name is derived from the Portuguese word '*barroco*', which refers to a rough or imperfect pearl. Similarly, baroque buildings are characterised by excrescence and irregularity. The style used extravagant theatrical effects to produce intense drama and grandeur.

The crowning glory of English baroque architecture is St Paul's Cathedral (1675–1708), which evokes the great domed churches of Italy. Meanwhile, England's ruling elite were building baroque houses as expressions of their wealth and longevity. A local example is Seaton Delaval in Northumberland (1718–28) by Sir John Vanbrugh. Significantly, Etty had worked as Vanbrugh's clerk of works at Castle Howard, and this project may have influenced his design at Sunderland.

The new church was a seat of local government as well as a place of worship. At the west end is the vestry, a large chamber that hosted monthly parish meetings. Twenty-four elected officials met around an oak table that still survives in situ. In contrast to the medieval churches in the town, Holy Trinity was a bright, modern church for a new age of prosperity and progress.

5. Queen Street Masonic Hall

The Freemasons' Hall in Queen Street is the oldest purpose-built Masonic hall still used for its original purpose in the world. This extraordinary fixture of Sunderland's townscape is a gem of Georgian architecture that has miraculously survived amid the urban sprawl of the twentieth century.

The hall was built in 1784–85 to rehouse the King George Lodge, after the original building in Vine Street was destroyed by fire in 1783. The name Phoenix Lodge was adopted in reference to this resurgence from the flames. The intention was to build a hall similar to the original, and this task was completed by John Bonner (1741–1811), a member of the lodge who worked as a builder and joiner. Bonner was from the family of timber merchants who gave their name to Bonnersfield on the north bank of the Wear. The hall was built at a cost of £600, of which £360 was raised by the brethren in £20 shares.

The façade is a simple classical design in plain brick. As befits a 'society of secrets', the exterior is purposefully inscrutable, but features the Masonic symbols of a square and compasses. Unusually, the hall was built upon stone pillars, which allowed a cellar with an earth floor to be formed beneath.

The beautifully preserved interior has an aura of great solemnity. The main chamber was built as a double cube, a form with symbolic resonance in Masonic tradition. In this case,

Figure 7. The inner chamber of Queen Street Masonic Hall.

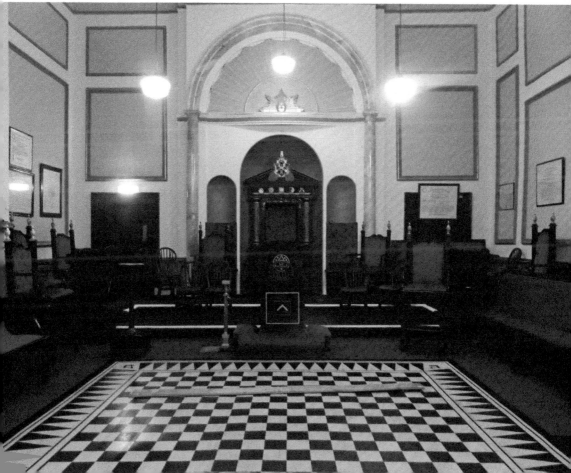

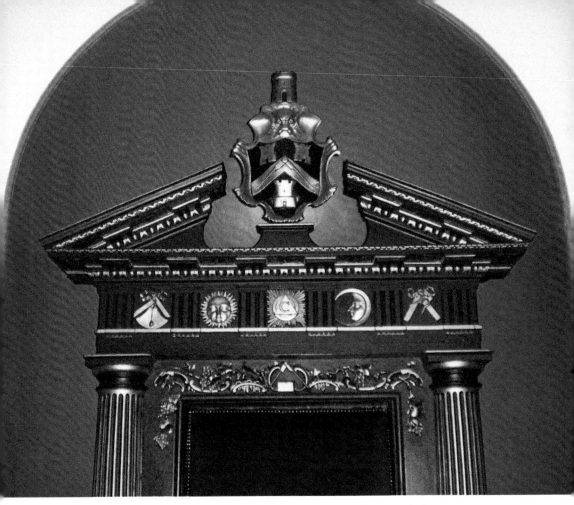

Figure 8. The Worshipful Master's throne is replete with Masonic symbolism.

the shape was also dictated by the site, which was previously occupied by a bowling green. The walls are lined with plaster panelling and adorned with gilded symbols and crests, some of which were reproduced from the previous hall. Solar and lunar emblems were carved by a Brother Pears at a cost of £30. The chairs were acquired from St John's Lodge in Newcastle.[6]

At one end of the chamber stands a dais supporting the Worshipful Master's throne, a majestic seat based on classical architectural elements, in celebration of the stonemason's craft. Behind the throne are wooden columns painted to resemble marble, which support an extraordinary golden sunburst. The dais originally featured twin spheres representing the celestial and terrestrial realms, but these were damaged in 1947 and removed.

The floor is lined with black and white tiles, a Masonic leitmotif said to be derived from the Temple of Solomon in Jerusalem. This ancient reference is contrasted with a modern one: the twin fireplaces were designed in the fashionable 'Adam style' popularised by the Scottish neoclassical architect Robert Adam (1728–92). The walls feature a number of 'tracing boards' dating from c. 1811. Replete with mysterious symbolism, these are used as teaching aids when a master explains the concepts of Freemasonry to new members.

At the opposite end of the chamber is an organ (1784–85) made by the master craftsman John Donaldson (d. 1807) at a cost of £50. This is the only example of Donaldson's work still in its original location. The building was extended by J. W. H. Swan in 1890, providing a banqueting hall at a cost of £379. The Freemasons' Hall remains a nationally important example of a Masonic lodge, boasting one of the best Georgian interiors in the region.

6. Sunderland Exchange

The Exchange Building on High Street (1812–14) was the administrative, commercial and cultural centre of the developing town. The Improvement Act of 1809 prompted Sunderland's Improvement Commissioners to build the Exchange as a town hall, courthouse, post office and market. A site on High Street East was purchased from Sir Henry Vane Tempest, located midway between the two settlements it was meant to serve. Funds of £8,000 were raised by public subscription in £50 shares.

The Exchange was designed by father-and-son architects John and William Stokoe of Newcastle, who contributed significantly to the development of neoclassical architecture in the region. Their most important work was the Moot Hall in Newcastle (1810–12), one of the first Greek Revival buildings on Tyneside. John Stokoe (c. 1756–1836) probably gained his expertise from the building trade, but his son William (c. 1786–1855) may have received architectural training in London or Edinburgh, and exhibited at the Royal Academy in 1808. Historians have perhaps underestimated the abilities of the Stokoe dynasty because they were soon eclipsed by the region's pre-eminent architect, John Dobson.

Figure 9. The polite façade of the Exchange Building.

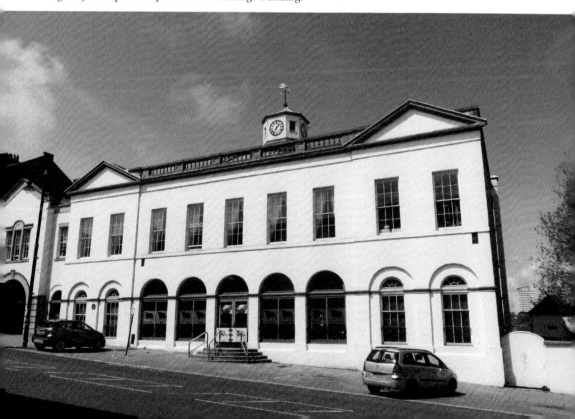

The selection of the Stokoes for the Exchange project suggests that there was no architect in Sunderland capable of undertaking such an important commission at this date. Given that a general contractor was also employed, it is possible that William Stokoe was trying to establish himself as an architect. The contractor in question was George Cameron of Esk, grandfather of chemist Joseph Swan (1828–1914), who invented the incandescent electric light bulb in 1878.

The design of the Exchange is a distant echo of the Palladian style that developed from the work of Italian Renaissance architect Andrea Palladio (1508–80). Palladio developed formulae for houses and villas based on Roman models. Crucially, he published his designs in *I quattro libri dell'architettura* (1570) and this disseminated his principles internationally. During the Georgian period, a cultivated circle of architects and patrons embraced Palladianism between *c.* 1715 and 1760.

The wide expanse of the façade is clad in stucco, but the rear and side elevations reveal the underlying stone construction. Pavilions project at either end in the Palladian manner, surmounted by triangular pediments. A balustrade along the roofline adds delicacy and refinement, while the octagonal clock turret made the building a notable landmark.

When the Exchange was opened in 1814, it assumed the administrative functions of Holy Trinity Church. The Improvement, Bridge and River Wear Commissioners occupied the principal rooms on the first floor, which could also be used for public functions. A newsroom offering local and metropolitan papers was included, along with space for magistrates. Behind the arcade was a piazza-like space for markets, while the basement contained a police station, kitchens and vaults. Overall, the Exchange was a complete public building, fully equipped for the central role it would play in the administrative and commercial life of the town.

Towards the end of the nineteenth century, the building became the Seamen's Mission and alterations were carried out, including the glazing of the arcade. Tyne and Wear Development Corporation restored the building in 1998. Modern excavations uncovered a glass vessel containing a piece of vellum listing the names of the original subscribers, who included prominent members of Sunderland's entrepreneurial class.

7. St George's Chapel

Sunderland's architecture was growing in sophistication during the early nineteenth century as local builders began to embrace established architectural styles and aesthetic principles. St George's Presbyterian Chapel in Villiers Street (1825) was one of the first neoclassical buildings in the town and laid the foundation for the more polite architecture that followed.

Replacing an earlier chapel in Robinson's Lane, St George's was a grand building that denoted the growing status of the Presbyterians within the town.[7] It was designed by the local builder James Hogg (1785–1838), who was the first person in Sunderland to be described as an architect in local directories, after several years' experience in Oxford and London. Hogg was one of many builders in this era who aspired to higher professional status. Architecture later developed into a properly regulated profession and a number of fully qualified practitioners emerged from Sunderland.

St George's Chapel is a design of striking austerity. The façade is dominated by a triangular pediment, supported on bold Doric pilasters, or flat-faced columns. These are the basic elements of classical architecture and give the building the stern dignity of a Greek temple. The classical style was devised by the Ancient Greeks in the fifth century BC and subsequently developed by the Romans. It was later revived as part of an international movement known as neoclassicism. Specifically, St George's is a product of the Greek Revival, a phase of neoclassicism that flourished *c.* 1750–1830 and drew on authentic Greek models.

However, there is one departure from strict classical formulae; with a builder's eye for practicality, Hogg separated the central pilasters to improve access, a gesture that cultivated architects would have considered a solecism. Despite its shortcomings, the chapel anticipated later neo-Greek marvels such as the famous Penshaw Monument (1844).

Aside from the façade, the chapel was mainly built in the coarse magnesian limestone that typifies Wearside's vernacular buildings. Standing alongside is a former schoolhouse (1849–50) designed in the style of an Italian palazzo by Thomas Oliver Jnr (1824–1902). The chapel became rather isolated as the commercial heart of the town shifted westwards and now operates as a business centre.

Figure 10. St George's Chapel invokes Ancient Greek temple forms.

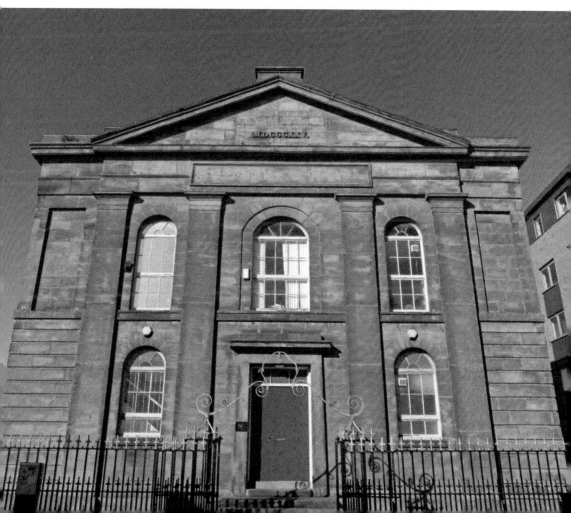

8. St Mary's RC Church

The building that introduced the Gothic Revival to Sunderland was St Thomas' Church at the corner of John Street (1829), but this was destroyed during the Second World War. Sunderland's oldest surviving neo-Gothic building is St Mary's RC Church on Bridge Street (1830–35). Built soon after Catholic Emancipation, it reflected the resurgence of Roman Catholicism after centuries of oppression.

Local Catholics had worshipped in a private residence in Warren Street and an obscure chapel in Dunning Street before the Catholic Emancipation Act of 1829 gave them the freedom to practise their faith. In the same year, Father Philip Kearney arrived from Ireland and purchased a site from the Earl of Durham for a new church.

Designs were provided by Ignatius Bonomi of Durham (1787–1870).[8] Best known as the architect of Durham Gaol, Bonomi had been trained by his father, who had migrated from Italy and developed a large practice in country houses. John Dobson recognised Ignatius as the only architect of note between York and Edinburgh, besides himself, and his works included Catholic churches, country houses and official projects.[9]

The façade was designed in the Early English Gothic style, which flourished *c.* 1189–1307 and makes a spirited display of medievalism, consciously evoking the universal Catholic Church of the Middle Ages. However, Bonomi was primarily a classicist, and St Mary's is essentially a classical preaching box hidden behind a Gothic façade.

Figure 11. St Mary's RC Church is Sunderland's oldest Gothic Revival building.

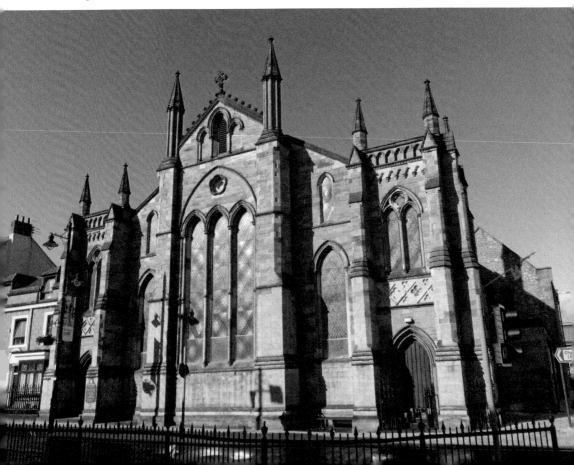

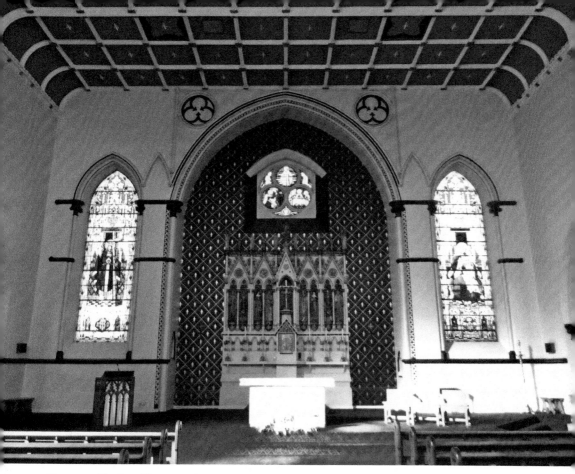

Figure 12. The box-like nave of St Mary's.

The interior is a box-like space of late Georgian character. The flat ceiling is the antithesis of the soaring vaults typical of medieval churches and the chancel, rather than being a separate space enshrining the altar, is merely a shallow recess in the west wall. This naïve use of Gothic motifs is typical of the early Gothic Revival, when architects used medieval forms with little understanding of correct grammar. Nevertheless, the chancel is furnished with an elaborate reredos replete with statues of northern saints.

Typically for a Georgian church, there is a gallery at the rear. Galleries fell out of favour in the Victorian period, but were essential for accommodating large congregations swelled by Irish migrants. By 1851 there were over 4,000 Irish-born immigrants in Sunderland. To accommodate the growing congregation, two side chapels were added in 1852.

The frontage is of dressed stone, but the other walls were built of rough limestone to reduce costs. As early as 1850, the *Sunderland Herald* commented that the stone mouldings were beginning to crumble, the stone from Morpeth 'being rather susceptible to the influences of the atmosphere.'[10] The church was damaged by air raids in 1943 and much of the stained glass was replaced in 1946–47 by the Dutch firm of Jansen & Co. using funds from the War Damage Commission. In 1982 the church was reordered in line with the liturgical changes of the Second Vatican Council. The pulpit and altar rails were removed and a new forward altar and font were introduced.

9. Trafalgar Square

Trafalgar Square is one of the few surviving monuments to Sunderland's rich maritime heritage. As a port, Sunderland had many aged or sick mariners to care for, as well as their dependents. Almshouses were built at the Assembly Garth in 1727, but further provision was soon needed.

In 1747, an Act of Parliament created the Muster Roll Fund for the 'relief and support of maimed and disabled seamen, and their widows and children of such as shall be slain, or drowned in the Merchant Service.' In 1840, this fund was used to build Trafalgar Square in Church Walk, a complex of fourteen almshouses for 104 elderly merchant seamen. Built on the site of the workhouse garden, the almshouses were named after Nelson's legendary naval victory of 1805, at which seventy-six sailors from Sunderland were present. In fact, Sunderland's Trafalgar Square was opened five years before its famous namesake in London.

The almshouses were probably designed by William Drysdale (1793–*c.* 1856), a builder and surveyor who undertook occasional work for the Corporation.[11] The two-storey houses are built of plain brick, laid in English garden wall bond, with stone dressings over the windows. The houses are built around three sides of a quadrangle, framing a garden.

Figure 13. Trafalgar Square is a relic of Sunderland's maritime history.

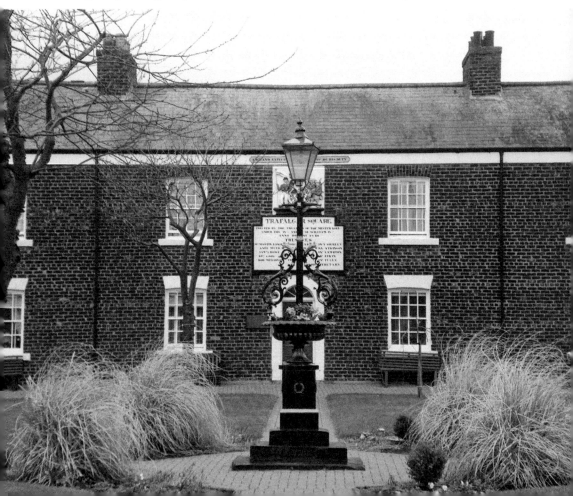

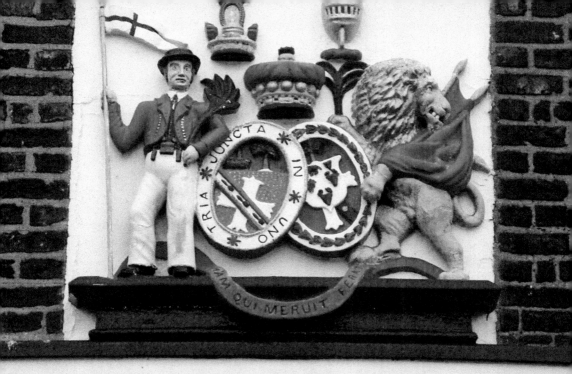

TRAFALGAR SQUARE.

Figure 14. An elaborate plaque bearing the arms of Admiral Nelson.

The main feature is a plaque above the door of the central house, which records the building of the almshouses and the names of the trustees. Above this is a brightly painted relief based on Nelson's heraldic banner. The execution is crude but vivid, with figures of a sailor and lion holding escutcheons. Around one of these is written '*Tria Juncta in Uno*' – 'Three joined in one.' This is the motto of the Order of the Bath, a chivalric honour that was presented to Nelson by George III for defeating the Spanish fleet at the Battle of Cape St Vincent in 1797.

Surmounting the whole composition is the famous signal reputedly sent by Nelson at the Battle of Trafalgar, 'England expects every man to do his duty.' At the edge of the green is a large display giving the names of the local men who fought in the battle and details of the ships they served on. The almshouses have since been refurbished as modern flats.

10. Monkwearmouth Station

Monkwearmouth Railway Station (1848) is the finest classical building in Sunderland. The symmetrical design is a sophisticated example of Greek Revival architecture, based on the purest models of antiquity. With its stately Ionic portico, it was one of the most elegant railway stations in the country.

Sunderland's railways developed in tandem with the coal trade, as expanding rail networks allowed coal to be brought from neighbouring pits to the river. Railway

companies soon realised that passenger as well as goods traffic could be profitable, and this demanded the building of more aesthetically pleasing stations. The prime mover behind the railways was George Hudson (1800–71), the infamous 'Railway King', who built Monkwearmouth Station as a gift to the town following his election as MP for Sunderland in 1845. The station was built close to Wearmouth Bridge, which, along with the stately design, indicates that it was intended for passenger rather than goods traffic.

To design the station, Hudson acquired the services of the town's most respected builder-architect of the early Victorian period. Considered 'the father of his profession' in Sunderland, Thomas Moore (1794–1869) had designed a number of mansion houses for private clients, and his sophisticated grasp of neoclassical taste culminated in a remarkably assured design for the station. The design is an example of Greek Revival architecture, a branch of neoclassicism that discarded grandiose Roman elements in favour of the purer, starker forms of Greek antiquity.

Knowledge of Greek classicism was disseminated by antiquarians who studied ancient ruins and published meticulous measured drawings. Moore's design for the station was inspired by a specific building from antiquity, the Temple of Artemis Agrotera near Athens (c.435–430 BC). Often known as 'the Ionic Temple on the Ilissus', this structure was best known from illustrations published in James Stuart and Nicholas Revett's monumental study, *The Antiquities of Athens* (1762). Unfortunately, the temple itself was destroyed

Figure 15. Monkwearmouth Station is an assured exercise in academic classicism.

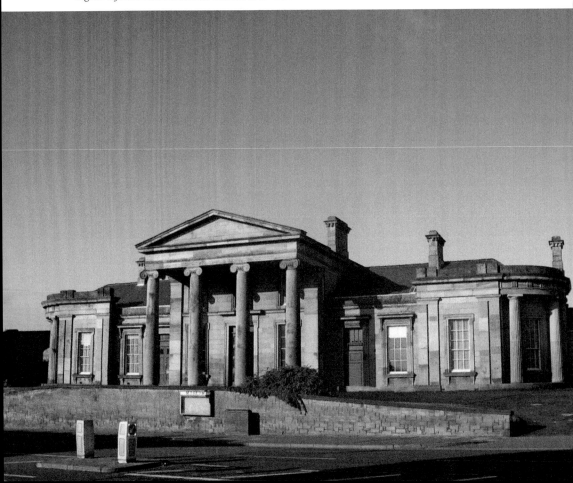

by the Ottoman Turks in around 1778. Monkwearmouth Station's tetrastyle portico is a facsimile of that illustrated by Stuart and Revett, while the Ionic capitals reproduce the decorative details, including a graceful swag between the volutes and a series of ovolos (egg-shaped mouldings).

Moore integrated these erudite references into his own sophisticated design. The symmetrical composition is dominated by an imposing portico with a triangular pediment carried on four columns of the Ionic order. The side wings recede in quadrant curves and the rounded entablatures are supported on fluted Doric columns. Following correct Greek models, these columns are without bases, resting directly upon the stone plinth.

The central block housed the ticket office and accommodation for the stationmaster, while a first-class waiting room with moulded plaster ceiling occupied the south wing and a simpler second-class waiting room lay to the north. The platform is roofed with a glass canopy manufactured by the local glassmaker James Hartley & Co.[12] In recent years, the building operated as a transport museum, but this closed in 2015.

With its authentic neoclassical design and harmonious proportions, the building achieves a sedate elegance that belies its industrial purpose. Even the railway track is politely concealed behind a screen of round arches and pilasters. The architectural historian Sir Nikolaus Pevsner famously quipped: 'If one does not mind a railway station looking like a Literary and Scientific Institution or provincial Athenaeum, then Monkwearmouth is one of the most handsome stations in existence.'[13]

11. Hutchinson's Buildings

Hutchinson's Buildings on the corner of High Street and Bridge Street (1850–51) signalled the 'march of improvement' in Sunderland.[14] This strident classical edifice was built by the timber merchant Ralph Hutchinson as a commercial venture, with shops on the ground floor and residences above. Emulating the classical buildings of Newcastle, it helped to raise Sunderland's architectural profile.

The building was erected on the site of Dr Clanny's garden. An Ulsterman by birth, William Reid Clanny (1776–1850) was appointed chief physician at Sunderland Infirmary in 1831 and was among the first to recognise the true nature of cholera. He was also the first person to conceive the idea of a miners' safety lamp. Plans to redevelop the site were provided by George Andrew Middlemiss (1815–87), who was a powerful figure in Victorian Sunderland.

Beginning as 'a lowly toiler' with the building firm of J. C. Tone, Middlemiss had no formal architectural training, but was describing himself as an architect, surveyor and auctioneer by 1847.[15] Given that he also owned a brickworks and served as a Conservative councillor, it is no surprise that Middlemiss was centrally involved in housing development, as he was able to provide not only the designs, but also the bricks and the political acumen to navigate the byelaws. Indeed, he built much housing outside the borough boundary in order to avoid sanitation laws. His reputation was made by Hutchinson's Buildings and observant viewers may notice his name inscribed just below the dome.

The grand elevations are divided by a mighty corner drum. Giant pilasters scale the walls, but the drum is surrounded by fully rounded columns of the Corinthian order, which is characterised by richly carved capitals based on the image of acanthus leaves

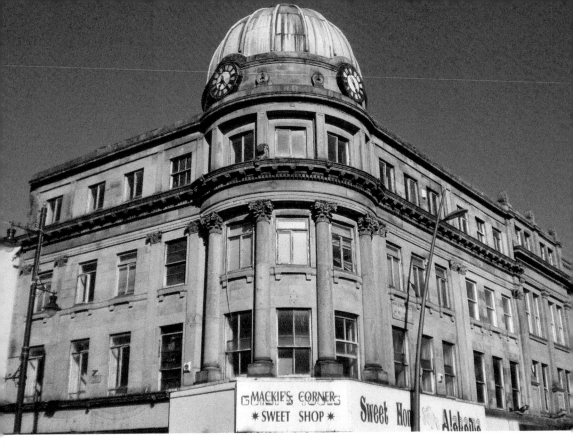

Figure 16. The powerful classical forms of Hutchinson's Buildings.

growing around a votive basket. A stark entablature rests upon the columns and gives the façades a powerful unity. Crowning the composition is a dome embellished with clock faces and scallop shells. This classical splendour was achieved with high-quality stone from the Craigleith and Binny quarries in Scotland, both of which had produced stone for the building of Edinburgh's classical New Town.

The design deliberately echoed Richard Grainger's celebrated replanning of Newcastle in the 1830s. In particular, the corner drum is reminiscent of Newcastle's Central Exchange (1837–38). However, while Newcastle had the visionary Grainger to devise a unified urban plan, Hutchinson's Buildings remained a solitary example in Sunderland.[16] The building was much admired when it was completed, with the *Sunderland Herald* stating, 'In point of magnitude, classic beauty, arrangement and proportions, and unity of design it will bear the bell away from all other property erected as yet for similar purposes in town.'[17]

Once completed, the building boasted 'spacious first-class shops' with glazed frontages.[18] These were supported by cast-iron stanchions made at Joseph Lee's Phoenix Foundry, set on large limestone blocks from Building Hill. The upper storeys offered self-contained dwellings, each with 'ample and airy rooms, and being furnished with every requisite to make it an elegant and comfortable residence.'[19] The eastern part of the building was severely damaged in a catastrophic fire of 1898 and subsequently rebuilt by Joseph Potts and Son to a different design (1898–99). This junction is still known as 'Mackie's Corner', after a silk hat-maker who occupied the building for many years.

12. Bede Tower

Bede Tower in Ryhope Road (1851) was built for solicitor Anthony John Moore, who was mayor of Sunderland from 1854–55. It was designed in the Italian Renaissance style, but the treatment is very informal in order to satisfy English domestic tastes. Even with these homely touches, the Italianate design is a welcome contrast to the heady Gothicism of Ashbrooke's other grand houses.

This charming villa was designed by father-and-son partnership John (1787–1852) and Benjamin Green (*c.* 1811–58), who were responsible for some of the finest classical buildings in the region, including Grey's Monument in Newcastle (1838). At Bede Tower, they used the classically derived Italian Renaissance style that was fashionable during the 1850s. To achieve an appropriately domestic character, however, the architects included prominent overhanging eaves on white brackets. The main block is articulated with subtle quoins and a tall bay window emerges from the second bay, deliberately avoiding symmetry.

Originally standing on the edge of tranquil countryside, the villa projected its Renaissance aesthetic into the landscape in the manner of the Picturesque movement. Designed to maximise the surrounding view, the diminutive belvedere tower was derived from those of Osborne House, Queen Victoria's summer residence on the Isle of Wight (1845–51). Bede Tower was owned by the University of Sunderland for several years and much extended, but now operates as Bethany City Church.

Figure 17. Bede Tower is a charming Italianate villa.

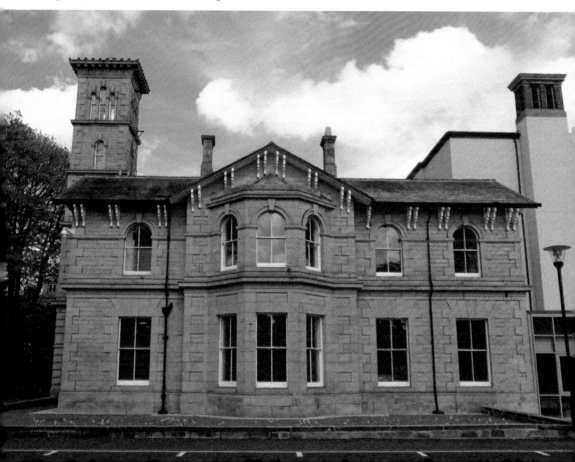

Figure 18. Painting of Bede Tower in its original setting *c.* 1854. (Sunderland Antiquarian Society)

13. Mowbray Almshouses

The Mowbray Almshouses in Church Lane form a charming group of cottages on the crest of Bishopwearmouth green. The rich Gothic design is based on the charitable almshouses of the Middle Ages and complements the medieval church of St Michael nearby. Together the buildings form a delightful enclave of tranquillity within the bustling city.

Jane Gibson, the widow of a prominent local merchant, bequeathed money to establish almshouses for 'twelve decayed old women who have been in better circumstances' and these were built in 1725–27. Elizabeth Gray Mowbray funded the building of the present almshouses in 1863, after the Mowbray family inherited responsibility for their administration.[20]

The design is significant because it was an early work by Edward Robert Robson (1836–1917), an architect of national importance. Born in Durham, Robson trained in the office of Sir George Gilbert Scott (1811–78), the most prolific architect of the Victorian era. In 1870, he became architect to the London School Board and developed the template for the gargantuan board schools that were introduced by the Elementary Education Act of 1870. The Mowbray Almshouses were built during Robson's tenure as architect to Durham Cathedral, when he completed several commissions in the North East.

The buildings are strongly Gothic in style, demonstrating that the Gothic Revival had permeated domestic architecture by the 1860s. Emerging in the eighteenth century, the Gothic Revival was a crusade to resurrect the architecture and spiritual values of the Middle Ages. This revolution was led by the brilliant architect and designer Augustus Pugin (1812–52), who believed that Gothic was the only style fit for a Christian country. Following Pugin came a new generation of architects who had been trained in a Gothic Revival tradition and were able to design in an authentically medieval spirit.

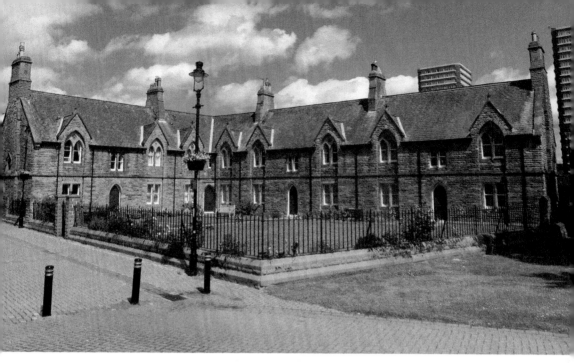

Figure 19. The Mowbray Almshouses revive medieval ideals of charity.

The Mowbray Almshouses follow Pugin's notion of reviving medieval ideals of Christian charity. The design consists of four cottages arranged in an L-shaped plan and overlooking an attractive garden. Each cottage has a central door set within a pointed Gothic arch. The first-floor windows are ecclesiastical in character, with twin lancets and plate tracery. Pointed gables enhance the Gothic spirit and the roofscape is embellished with red ridge tiles. The almshouses are built of rock-faced sandstone, with decorative details in ashlar. The gables end with clove-shaped finials and the stepped chimney-stacks feature Latin inscriptions and the Mowbray lion.

14. Christ Church

Christ Church in Mowbray Road (1862–65) was the first fully achieved Gothic Revival church in Sunderland. Built in the affluent suburb of Ashbrooke and partially funded by the glassmaker James Hartley (1810–86), it was an authentic neo-medieval design with cruciform plan, rich sculpture and splendid stained glass.

Ashbrooke was developing into the town's most prestigious new suburb, where successful entrepreneurs and professionals could escape the overcrowding and pollution of the town centre. To obtain a church of appropriate status, an architectural competition was held in 1862. This was won by the young architect James Murray (1831–63) of Coventry. Murray trained in Liverpool and had worked in partnership with E. W. Pugin (1834–75), the son of the great polemicist of the Gothic Revival, and was well qualified to design in a medieval spirit. The prominent site on the corner of Ryhope Road and Mowbray Road was sold by the Quaker banker Edward Backhouse, whose only proviso was that the church be given a good spire.

Figure 20. Christ Church is an authentic neo-medieval design.

The body of the church consists of a broad nave, distinct chancel and transepts forming the shape of a cross. Rising above the side aisles, the clerestory is pierced by quatrefoil windows. Following authentic medieval precedents, a fully formed chancel projects at the east end and enshrines the altar. The most striking feature is the soaring tower and broach spire, which was placed at the north-east corner to assert the church's presence on Ryhope Road. Although the stonework is conducted in a rustic spirit, the sculptural elements are extremely rich. Monstrous gargoyles and emblems of the Evangelists appear on the faces of the tower and vigorous naturalistic carving abounds.

The interior unfolds with typical High Victorian splendour, divided into nave and side aisles by Gothic arcades with marble piers and foliage capitals. The fine east window originally encapsulated a bright array of stained glass (1864) by Morris, Marshall, Faulkner & Co., the most important firm associated with the Arts and Crafts movement. The emphasis on stained glass was probably due to the influence of James Hartley, who gave most of the money to build the church. The glass was removed when the church closed in 2000 and installed in Sunderland Minster, where it can be seen today.

The total cost of the church amounted to £7,184. Sadly, the architect, James Murray, never saw the building completed; he died during construction and his former assistant, John Cundall (1830–89) of Leamington Spa, took over the supervision.[21] In later years, a ceremonial cross was given in memory of Sunderland's own Arts and Crafts architect C. A. Clayton Greene (1874–1949), who was a member of the congregation.

The building closed for Christian worship, but was purchased by Sunderland's Sikh community in 2000. The church became a community centre, while the former church hall is now used as a Gurdwara or Sikh temple. In recent years, the tower has become unstable and is currently covered with protective netting.

15. Gas Company Offices

Fawcett Street developed into Sunderland's main commercial thoroughfare in the late nineteenth century. This shift was signalled by the head office of the Gas Company (1867) at the end of the street. The confident design was provided by George Gordon Hoskins (1837–1911) of Darlington, who specialised in Gothic architecture for secular purposes. Hoskins designed the Backhouse Bank on High Street (1868) in a very similar style and was also responsible for Sunderland's most notorious building, the Victoria Hall (1872), which was the scene of a disaster in 1883 when 183 children were crushed to death at a children's show.

The Gas Company office was one of the first examples of High Victorian Gothic architecture in Sunderland. Flourishing c. 1850–70, this phase of the Gothic Revival was based on hard, angular forms and vibrant multicoloured façades. For this reason, it was humorously nicknamed the 'streaky bacon style'.

The building's muscular massing is typical of this idiom. Pointed dormer windows burst from the roofscape and an oriel window projects from the centre, resting upon a granite column with carved foliage. The façade is a splendid example of 'structural polychromy', in which colour was built into the fabric by the use of multicoloured building materials. In this case, red and blue bricks are combined with sandstone to produce a vibrant patterned surface. The building also reveals the influence of Venetian architecture,

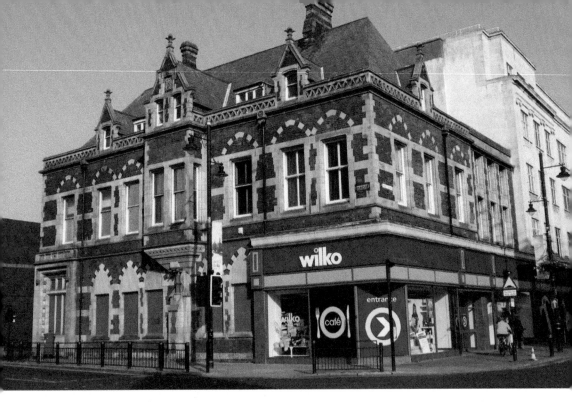

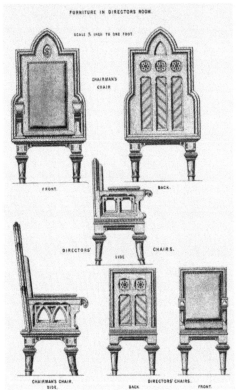

Above: Figure 21. The brilliant polychrome façade of the Gas Company Offices.

Left: Figure 22. Gothic furniture for the Gas Company Offices.

which was popularised by art critic John Ruskin (1819–1900) in his monumental book, *The Stones of Venice* (1851–53).

Hoskins also designed furniture for the building, including chairs for the chairman and directors, executed in oak with ebony inlay.[22] The architect's brother, Walter Hamlet Hoskins (1845–1921), was a director of the North of England School Furnishing Company and may have been involved in manufacturing the furniture.[23] For many years the building was part of the sprawling Binns department store and is now owned by Wilkinsons. Sadly, much of the original brickwork has been replaced with a modern shopfront.

16. Ashbrooke Tower

The leafy suburb of Ashbrooke developed into the preferred residential quarter for Sunderland's wealthy industrialists and professional middle classes. Large houses and polite terraces were built in a range of fashionable styles. In 1875, the architect and builder G. A. Middlemiss designed Ashbrooke Tower for his own occupation, a medieval fantasy in a suburban enclave.[24] Here he lived in his final years, tended by his daughter after the death of his second wife, Anne.

Middlemiss is best known for designing Hutchinson's Buildings on High Street, one of Sunderland's first true neoclassical structures. By contrast, Ashbrooke Tower was designed in the High Victorian Gothic style of *c.* 1850–70. Gothic houses were common in this period, but it is nevertheless surprising that Middlemiss' taste had veered from the classicism of Hutchinson's Buildings to full-blooded medievalism.

Figure 23. Ashbrooke Tower is a romantic suburban mansion.

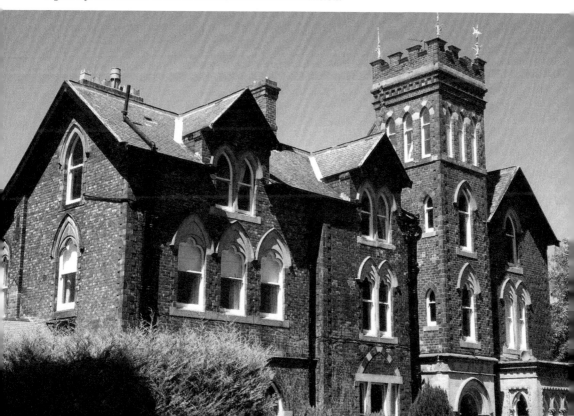

Ashbrooke Tower is wildly romantic in conception. Indeed, the Gothic style appealed to the imagination more than the intellect, favouring irregular plans, evocative silhouettes and fantastical ornament. The house is built of red brick with sandstone dressings, echoing the multicoloured façades of Venetian Gothic architecture, which, as we have seen, was much admired during the High Victorian period.

The entrance porch at the base of the tower is built of sandstone, with a moulded Gothic arch and red granite piers with foliage capitals. A square bay window juts out from the east wing, displaying similar details. The design culminates in a romantic skyline abounding with dormer windows, chimneys and a tower fortified with mock battlements. The interior housed a drawing room, sitting room and dining room, all embellished with ornate plasterwork and impressive fireplaces. Like many similar buildings, the property has now been divided into separate dwellings, but outwardly it remains Sunderland's finest Gothic Revival house.

17. Sunderland Museum, Library and Art Gallery

Sunderland Museum, Library and Art Gallery (1876–79) on Borough Road was the town's major cultural institution of the nineteenth century. The museum was founded in 1846 under the auspices of the Museums Act of 1845. Initially based in the Athenaeum on Fawcett Street, this was the first municipally funded museum outside London. The present building was erected to rehouse the growing collection.

The initial design by Councillor James Donkin was a cast-iron and glass structure based on the 'Crystal Palace' designed by Joseph Paxton (1803–65) to house the Great Exhibition of 1851. A site on Building Hill was chosen, but the site was subsequently moved to Borough Road to improve public access. The design was changed to incorporate a town hall and shops, but it remained essentially a glass structure. However, following a High Court ruling that only facilities to which the public would have access could be allowed in the park, the ambitious design had to be abandoned.

In 1867, a competition was held for a revised scheme for a museum, library and art gallery on the present site in Borough Road. This was won by an entry from the local brothers John (1835–99) and Thomas Tillman (1852–92), who were the first architects in Sunderland to operate in a fully professional manner, both achieving membership of the Royal Institute of British Architects. The design was executed at a cost of £12,000.

The building strives for a monumental effect, but the result is somewhat ponderous. Constructed of local coal measures sandstone, it merges grand classical elements with the French Renaissance style, which had a sporadic influence on British architecture in the 1870s and 80s. The powerful central block takes the form of a Roman triumphal arch and houses twin doors leading to the museum and library. The broad façade is bolstered by grand Corinthian columns and the outer bays are treated as pavilions.

A strong French influence is apparent in the climactic Mansard roofs that terminate the central block and outer pavilions. In this respect, the design may have been influenced by the Bowes Museum in Barnard Castle (1869), which was designed in the style of a French château. The original interior consisted of a grand entrance hall with staircase, and large salons with galleries and rich wood panelling.

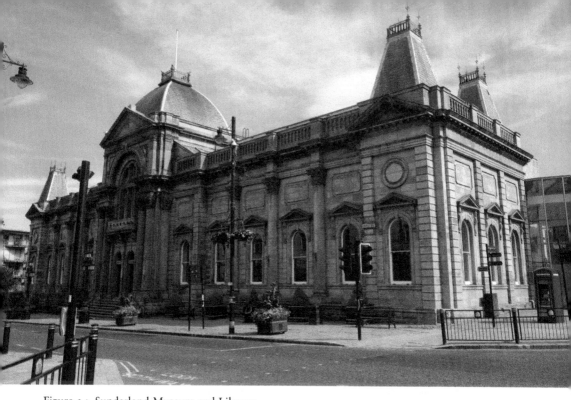

Figure 24. Sunderland Museum and Library.

Figure 25. The new Winter Gardens. (Sally Ann Norman)

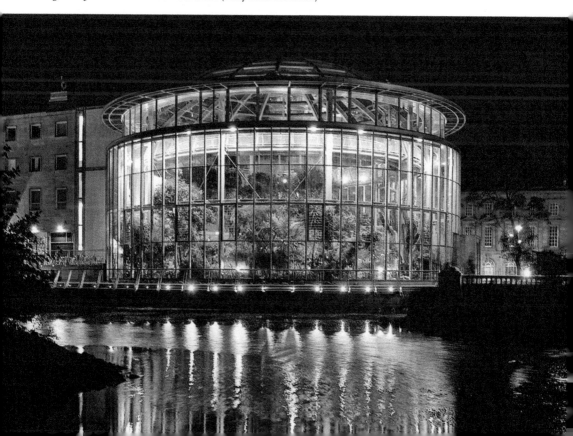

The foundation stone was laid by Alderman Samuel Storey in 1877 and the ceremony was attended by former Civil War general and US President Ulysses S. Grant, during a two-year world tour following his presidency. Immediately behind the museum stood the original Winter Gardens, a cast-iron and glass structure that echoed the design originally intended for the site.

Unfortunately, the Winter Gardens were destroyed during an air raid in 1941 and a modern extension took its place (1960–64). This was designed in the style associated with the Festival of Britain (1951), complete with slate cladding and a waveform canopy. The museum was extensively remodelled at the turn of the millennium, with the addition of the modern entrance at the corner of Burdon Road and a new Winter Garden (2000) by Napper Architects in the form of a glass rotunda.

18. National Provincial Bank

The National Provincial Bank (1876) on High Street is the finest of several bank buildings in Sunderland's commercial centre. Erected by one of the first banking corporations to establish a nationwide branch network, it introduced a note of metropolitan sophistication to Sunderland architecture. The building was designed by the bank's official architect John Gibson (1817–92), who produced over forty branches for the firm. Gibson had previously worked as an assistant to Sir Charles Barry (1795–1860), which gave him a thorough knowledge of classical and Renaissance vocabularies.[25]

Figure 26. The National Provincial Bank.

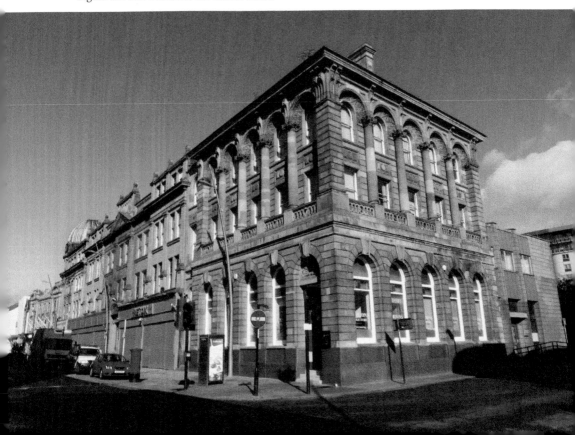

The Sunderland branch is an unusually rich expression of the Italian Renaissance style. All three storeys have strong rusticated stonework to inspire confidence in the bank's impregnability. The ground floor is punctuated by round-headed arches with elaborate keystones. Ionic columns of exceptionally fine workmanship scale the upper storeys, between shell-shaped arches with rich ornamentation. Crowning the building is a fine entablature with jewelled brackets and cornice. The dignified façade encapsulated a banking hall, offices and residential quarters for a caretaker. Gibson was an architect of national standing and Sunderland is fortunate to possess such a fine example of his work.

19. Elephant Tea Rooms

The Elephant Tea Rooms on Fawcett Street (1873–77) is Sunderland's most exuberant building of the Victorian age. Designed by the inventive architect Frank Caws (1846-1905), in a style he described as 'Hindoo-Gothic', this marvelous aberration is a cross between an Italian Gothic palace and a Hindu temple.

The building was erected by the grocer Ronald Grimshaw, who established a small empire of retail outlets in the town. The vibrant façade is executed in red brick and terracotta, made by Doulton & Co. of Lambeth. Venetian influence is apparent in the colourful arches and horizontal banding, but the corner turret and spire are distinctly Oriental. Ruskin had championed the Gothic palaces of northern Italy, and designs based on such buildings were common in Victorian towns, but Caws was unusual in combining them with exotic styles from India.

Figure 27. The Elephant Tea Rooms is a splendid orientalist fantasy.

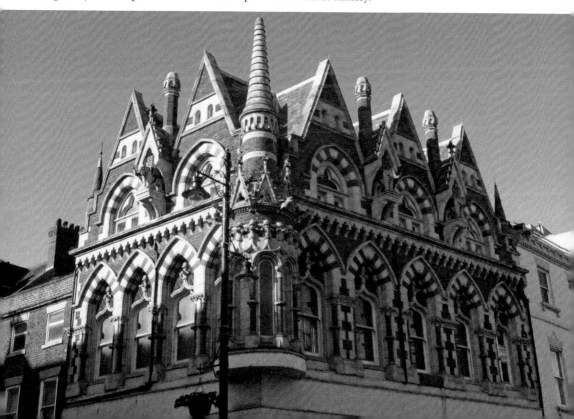

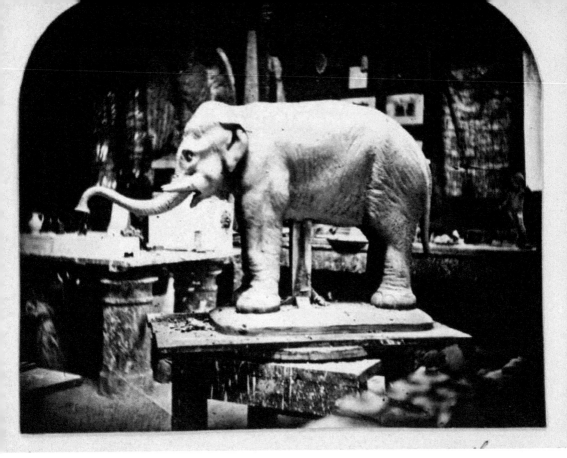

Above: Figure 28. A clay model at Doulton's workshop in Lambeth. (Sunderland Antiquarian Society)

Below: Figure 29. Frank Caws' sketch for a bazaar and exchange on Fawcett Street.

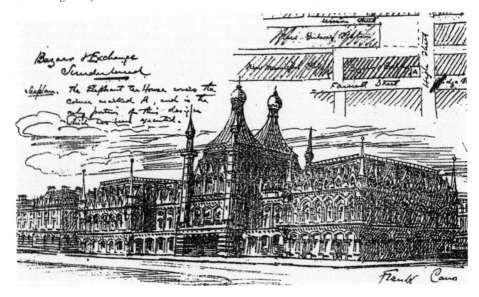

The design reaches greater heights of fantasy in the upper portions, where the roof erupts with gables, chimneys and extraordinary elephant gargoyles. In an ingenious touch, the elephants carry tea chests on their backs, indicating that the building was an emporium of exotic goods from the Orient. The corner turret resembles a Hindu pagoda, but abounds with Gothic details, including a cluster of vicious gargoyles. The ground floor was originally ornamented in similar fashion, with the turret resting on an elaborate fan vault.

Remarkably, Caws devised a fanciful scheme to develop Fawcett Street in similar style. In his sketchbook, he drew a Middle-Eastern-style bazaar and exchange that would have extended from High Street to St Thomas Street, with the existing component repeated at every corner. The centerpiece was an Islamic-style pavilion with exotic domes and turrets resembling the minarets of an Ottoman mosque. Sadly, this architectural fantasy never came to fruition.

20. Grange Chapel

Grange Chapel in Cowan Terrace (1883) was built by the Congregationalists and demonstrates that Nonconformist denominations were exchanging their austere classical chapels for rich Gothic churches. Building funds were raised by selling the Ebenezer Chapel in Fawcett Street for commercial redevelopment. The important regional practitioner J. P. Pritchett (1830–1910) of Darlington provided a remarkable church with a sweeping bank of Sunday Schools at the rear. These were actually built first and the chapel was slotted in later.

The chapel was designed in the Gothic style of the late fourteenth century. The bulk is rendered in rock-faced stone, but shafts of red granite add flashes of colour to the rugged façade. The surging tower ends with an octagonal spire with fish-scale decoration, rising from obelisk pinnacles. The chapel's most remarkable feature is the bank of schoolrooms at the east end, arranged in the manner of an ambulatory (a semicircular passage found in many cathedrals). The layout of the schoolrooms was influenced by American examples Pritchett had studied before undertaking the commission.[26]

Inside, the chapel is arranged on Nonconformist lines, with a pulpit rather than an altar at the focal point. Instead of a chancel enclosing the altar, the chancel arch is occupied by a fine Renaissance-style organ manufactured by Nelson and Co. of Durham. A gallery sweeps around three sides of the building, supported by slender cast-iron piers decorated with carved thistles. The plinths of these piers are painted with passion flowers and the names of virtues such as 'Brotherly Love' and 'Charity'.

A fascinating array of stained glass illuminates the interior. Two windows in the north gallery were salvaged from the Ebenezer Chapel on Fawcett Street. A small window in the north aisle (1926) is one of the last works by James Eadie Reid (1856–1928), a Scottish artist associated with the Arts and Crafts movement. This depicts the angel at Christ's empty tomb, telling the three Marys, 'He is not here, for he is risen.' Finally, there is a memorial window (1898) to Robert Whitaker McAll, founder of the Ebenezer Chapel. This is located under the gallery and can only been seen when the west doors are open: the sudden effect of light streaming through the window brings to mind the Biblical command, 'Let there be light.'

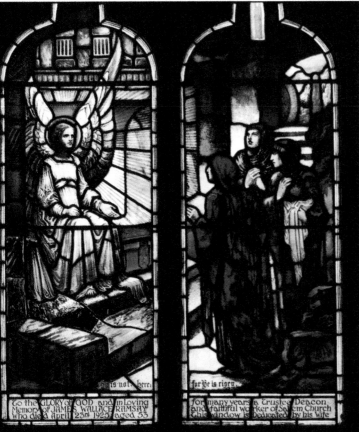

Above: Figure 30. Grange
Chapel with its sweeping bank
of apsidal schoolrooms.

Left: Figure 31. Splendid
window by James Eadie Reid.
(Dave Webster)

21. St John's Church, Ashbrooke

The pinnacle of Gothic architecture in Sunderland is St John's Wesleyan Methodist Church (1888), which stands like a cathedral amid the leafy avenues of Ashbrooke. The astronomical cost of the building was met by local residents, who were beginning to transform Methodism from a working-class faith into something that matched their own higher status. In doing so, they produced one of the best examples of Gothic architecture for a Nonconformist sect.[27]

Methodist places of worship are usually 'neat but not fine' in the words of John Wesley (1703–91), who founded the faith in the eighteenth century. However, St John's was built to put Methodism on equal footing with the established Anglican Church and embodies the pride, confidence and cultivation of its parishioners. At a cost of £17,000, it was the most expensive church ever built in Sunderland. The design was provided by Nonconformist architect Robert Curwen (1849–1915) of London. The contractor was J. H. Thorp & Sons of Leeds, using Prudhoe stone for the tower and Denwick stone for the interior.

St John's status as a church rather than a chapel is apparent in its arrangement, which follows medieval ecclesiology, although the east–west orientation is reversed. The plan is cruciform and the lofty proportions are enhanced by a piercing spire, which was designed to be taller than that of neighbouring Christ Church. A clear indication that the church was intended for affluent parishioners is a spiral stair turret that provides the only access to a servants' gallery in the north transept. This ensured separation of social classes. Indeed, the stairs were lined with lead to reduce the sound of footsteps as servants left services early to prepare coaches for their employers.

Rich sculpture abounds, much of it anticipating art nouveau, and every gable ends with a foliated cross. Even the wrought-iron door hinges are orchestrated into sinuous swirling patterns. Nestled between the gables of the north transept is a canopied niche that once contained a statue of the church's patron, St John. The provision of a lecture hall, band room and schoolrooms demonstrates the building's Methodist credentials, but they are laid out in the manner of medieval monastic planning.

Internally, the Methodist tradition has been adapted to fit an Anglican liturgical format. The nave is divided by pointed arches springing from slender round piers. The presence of side aisles precludes the sweeping galleries found in many Methodist chapels. Instead, the galleries are restricted to the east end and the transepts.

Facing each other along the main axis are superb stained-glass windows dedicated to the chief benefactors of the church: Thomas Coke Squance (1828–97), accountant and antiquarian, and John Wallace Taylor (1834–1927), ship owner, town councillor and member of the River Wear Commission. The Taylor window (1920) is particularly striking. Designed by the symbolist painter John Duncan (1866–1945), it depicts the Crucifixion in iridescent colours. The angels have lifelike feathered wings, perhaps reflecting Duncan's great interest in birds. A former pupil of William Wailes (1808–81) and William Bell Scott (1811–90), Duncan became a leading exponent of the Celtic Revival in Scottish art.

In true medieval fashion, the church has a fully formed choir beneath the high chancel arch. Nearby, the decorous pulpit is engraved with a line of scripture, 'Blessed are those who hear the word of God and keep it'. In a flash of potent symbolism, the brass handrail of the pulpit takes the form of a glistening serpent. The snake's tail is coiled like a Celtic knot, but the scales and fangs are alarmingly lifelike.

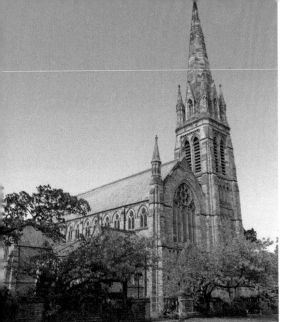
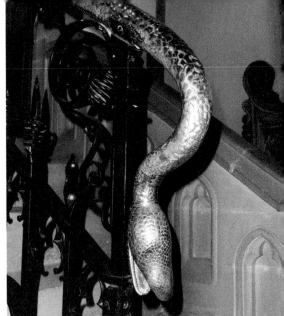

Left: Figure 32. St John's Wesleyan Methodist Church.

Right: Figure 33. The pulpit has a unique serpentine handrail.

22. St Ignatius' Church, Hendon

The church of St Ignatius the Martyr was built as a gift from the Bishop of Durham to inspire the working-class parishioners of Hendon. In 1889, Bishop Joseph Barber Lightfoot (1828–89) determined to build a church at his own expense to commemorate the seventh year of his episcopate. The working-class district of Hendon was selected as the worthiest parish, with a population 30,000 inhabitants, 'chiefly working men, who could not be expected to subscribe large sums'.[28] The resulting church is a good example of Victorian Gothic architecture and is surprisingly grand for a working-class parish. The internal layout and fittings were planned by Bishop Lightfoot himself.

The building was designed by Charles Hodgson Fowler (1840–1910), one of the leading ecclesiastical architects in the region. Fowler was born in Southwell, Nottinghamshire, the son of Revd R. Fowler of Rolleston. He was trained by the eminent Victorian architect Sir George Gilbert Scott and came to Durham in 1864, serving as architect to the Dean and Chapter from 1885 until his death. His practice was based on the restoration and design of churches and his designs were based on a sound archaeological knowledge of medieval buildings.

Built at a cost of £8,000, Fowler's church was designed in the Early English style, which was cheaper than later forms of Gothic architecture because it lacked elaborate tracery. A tower rises at the south-west corner, enriched with moulded openings and a tall broach spire. The west face of the church is pierced with long lancet windows typical of Early English Gothic, as well as an elliptical opening of Fowler's own invention. Outwardly, the building is very plain. Indeed, *Building News*, a leading architectural journal of the day, described it as 'very severe outside, as the smoke of a large town and the nearness of the sea would soon affect elaborate work, so all the ornamentation has been reserved for the

interior, but the exterior is a remarkably good piece of stonework'.[29] The stone itself was obtained from Edmunbyers quarry in County Durham.

The soaring interior culminates in a high altar raised on a dais of marble and backed with an elaborate reredos, an arrangement that followed advice from the bishop. Rich sculpture is framed by delicate tracery in the Perpendicular Gothic style. A representation of the Crucifixion is flanked by bishops of the East (Ignatius and Polycarp), and of the West (Cuthbert and Aidan). At the request of the bishop, the pillars dividing the interior resemble the clustered columns in the chapel of Auckland Castle, where he is now buried.

The chancel has a silver processional cross with emblems of the Evangelists and the Lamb of God on a background of blue enamel. This was made in 1913 by John Williams (1866–1951), a member of Charles Ashbee's Guild of Handicraft. Elsewhere, the church has metalwork by Arts and Crafts designer W. Bainbridge Reynolds (1855–1935), including a brass and enamel cross and matching silverware for the altar, which was brought here from another of Fowler's buildings, St Columba's Church, Southwick.

The bishop dedicated the church to St Ignatius, which is unusual in an Anglican context. As a theological scholar, he had published commentaries on the *Epistles of St Ignatius* in 1885 and was eager to commemorate the saint's works. Bishop Lightfoot fell ill during construction, but lived long enough to consecrate the church. After his death, Bishop Forrest Browne devised a full scheme of stained-glass windows. Those in the nave feature scenes from Bede's *Ecclesiastical Histories*; those in the chancel are based on the life of St Ignatius; finally,

Left: Figure 34. St Ignatius' Church was built for the hardworking people of Hendon.

Right: Figure 35. Window showing St Ignatius with a model of the church. (Dave Webster)

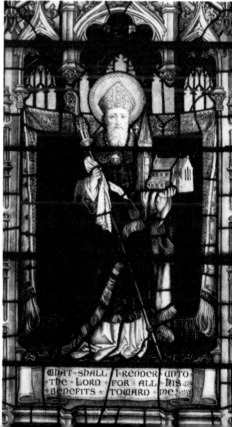

the west window illustrates the life of the church's founder. Produced by the renowned firm of Burlison and Grylls, these form a vast illuminated biography of the esteemed churchman.

23. St Columba's Church, Southwick

St Columba's Church, Southwick (1888–90) is one of the most distinctive churches in Sunderland. A brilliantly unified artistic achievement, the powerful design evokes the giant basilicas of Rome, while the interior houses superb stained glass and murals recalling the origins of Anglo-Celtic Christianity.

Built in the working-class district of Southwick, St Columba's Church was a striking statement of the High Church ministry that flourished there. It was probably the first vicar, Wilfrid Bird Hornby, who determined the building's overall character.[30] The dedication to St Columba and the fact that the fabric incorporated Irish stone suggests an intention to unify Celtic and Anglo-Saxon Christianity. St Columba was an Irish monk who founded an important abbey on Iona and is credited with bringing Christianity to Scotland.

The task of designing the church was entrusted to Charles Hodgson Fowler, the leading Anglican church architect in County Durham. Funds were limited and rather than build a meagre Gothic church, Hornby and Fowler reached into architectural history for a model that could be achieved within the budget. The design is based on the Romanesque basilicas of Italy and was realised at a relatively low cost of £4,300. Specifically, St Columba's is modelled on the church of Santi Vincenzo e Anastasio (1130–43) at Tre Fontane Abbey in Rome, which is reputed to be the site of the martyrdom of St Paul.

Figure 36. St Columba's Church was inspired by Roman basilicas.

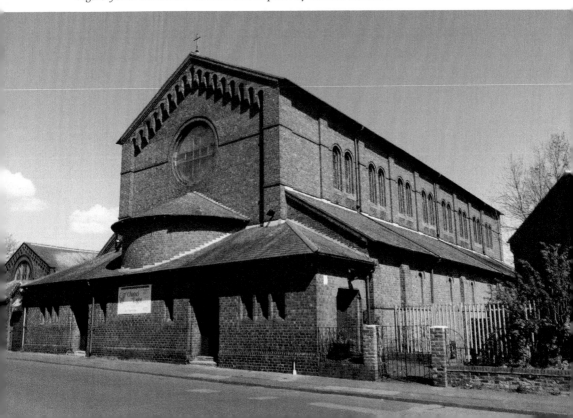

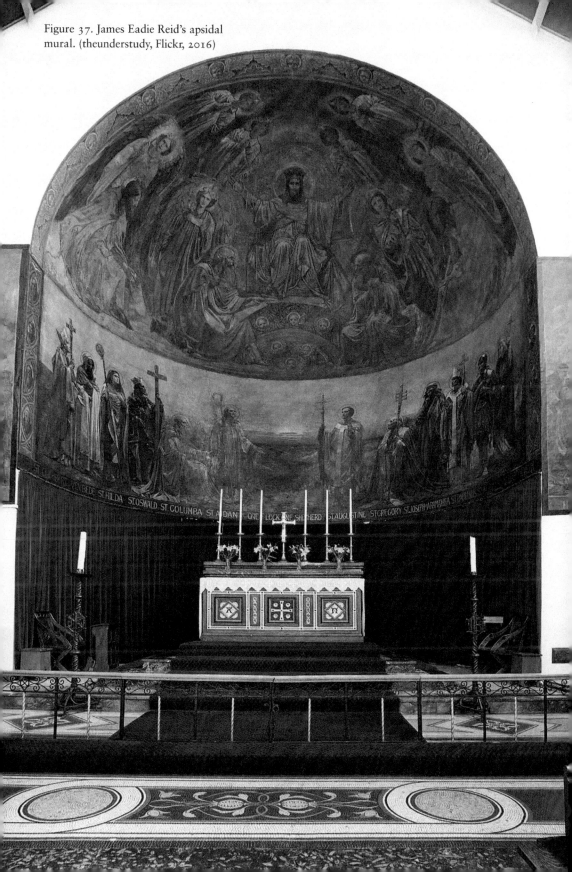

Figure 37. James Eadie Reid's apsidal mural. (theunderstudy, Flickr, 2016)

St Columba's is a vast basilican church that rises above the terraces of Southwick. The bulk is divided into a broad nave and side aisles, supporting an extremely high clerestory. The broad west face is pierced with a colossal wheel window in best Romanesque spirit and, below this, the bold form of an apsidal baptistery expresses itself with a conical roof. The powerful lines of the nave continue to the chancel, which ends with a semicircular apse. Brick construction gives the church a rugged dignity, as well as a symbolic connection to the surrounding houses, defining it as a church of the people. Fowler's plans included a campanile tower, but this was never built due to lack of funds. Overall, the grouping of the church with its later schools by Frank Caws (1893) and clergy house is undeniably powerful.

The interior is impressive in its uncompromising severity. Powerful Romanesque arches divide the space and lead the eye to a rich communion rail of multicoloured stonework. This incorporated green Connemara marble from Ireland, reminding us that the church is dedicated to the Irish missionary, St Columba. The chancel has a mosaic floor incorporating the local stone known as Frosterley marble, in fact a Carboniferous limestone containing fossils. There is also a square Romanesque font in dark marble.

The forms of the church are bold and monumental, but a note of richness was introduced in a series of murals by the Scottish artist James Eadie Reid, who was aligned with the Arts and Crafts movement and Ashbee's Guild of Handicraft. Painted between 1898 and 1924, these were inspired by Italian frescoes and Reid's visits to the Holy Land. The great apse was painted with a genuine fresco, but climatic conditions damaged the image and forced Reid to repaint it in oil on canvas. The subsequent murals were painted in the same manner, producing the largest collection of Reid's work anywhere.

The sequence illustrates the life of Christ, starting from the Annunciation in the Lady chapel and ending with the Ascension, the Enthronement and the Descent of the Holy Ghost at the east end. The apsidal mural depicts saints of the British Isles: Hilda, Oswald, Columba and Aidan, on one side of the River Wear; and the Romans Augustin, Gregory and Paulinus, with Joseph of Arimathea, on the other. Reid was also commissioned to design twelve windows, which were made by the Gateshead Stained Glass company. This celebration of early Anglo-Celtic Christianity perfectly complements the church's deliberately archaic design. After a period of neglect, the building now enjoys a new life as the Chapel of Light.

24. St George's Presbyterian Church

As Nonconformist denominations gained status, many gravitated from the East End to salubrious locations in Bishopwearmouth. The Presbyterians moved from their Grecian chapel on Villiers Street to a new Gothic church on Belvedere Road. St George's Presbyterian church (1890) was funded by the shipbuilder Robert Appleby Bartram (1835–1925), whose munificence accounts for the richness of the design. The architect was John Bennie Wilson of Glasgow (1849–1923), who elected to build the church in red sandstone from Dumfries in his native Scotland in order to symbolise the strong Scottish character of Presbyterianism. Much of the stonework is rock-faced, giving the church an appropriately rugged quality.

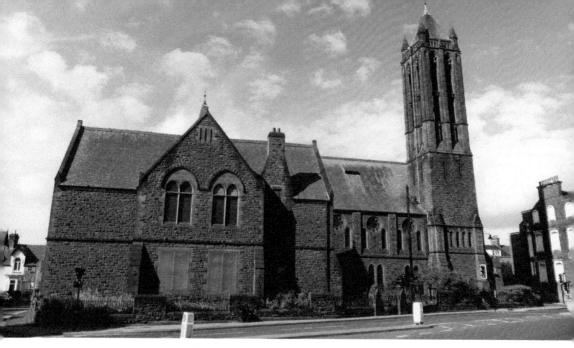

Above: Figure 38. St George's Church with its spectacular lantern tower.

Below: Figure 39. The internal planning follows the patterns of Presbyterian worship.

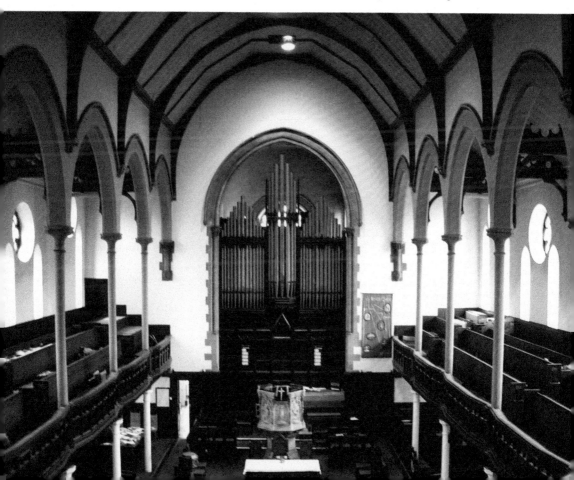

St George's was designed in the Early English style of the thirteenth century, which can be recognised by the use of plain lancet windows. The nave has extremely high side aisles to accommodate internal galleries, a standard feature of Nonconformist churches and chapels. The walls are pierced by unusual windows, consisting of a roundel between lancet openings. The church is an important landmark thanks to its highly original tower, which has an immensely tall belfry stage pierced with gaping lancets, creating a skeletal structure. With its unique silhouette, the church is a dominant element on the skyline.

The church in fact has a twin. Wilson had previously designed the Crescent Church on Linenhall Street, Belfast (1885–87) to an identical design, and the Building Committee of St George's asked him to reproduce it in Sunderland.[31] However, the use of Dumfries sandstone creates a very different effect from the grey rubble of the original, said to have been salvaged from ships' ballast.

The internal ordering follows Nonconformist patterns of worship. Aisles rise to the full height of the nave in order to accommodate galleries, and these are supported on cast-iron piers, creating an unimpeded flow of space. An ornate pulpit, rather than the altar, occupies the central position, declaring the primacy of word over ritual in Presbyterian worship. Chairs were provided for the elders of the church. There is no chancel; instead, the lofty Gothic arch at the east end is occupied by the organ. The building now serves as a United Reformed Church.

25. Corder House

Corder House and Sydenham House are among the architectural gems of Fawcett Street. Both were designed in 1889–91 by Frank Caws and rivalled the flamboyance of his own Elephant Tea Rooms. Corder House was occupied by Corder's shop, while Sydenham House is best remembered as Meng's Restaurant. Both buildings represent a fusion of Gothic and baroque styles, a combination that is highly unorthodox. The drapers Alexander Corder and Son opened a shop in Fawcett Street in 1884, which reportedly had a frontage with ironwork and enamel decoration. The shop was burnt out in 1888 and the company occupied temporary premises while building a replacement on the original site.

The resulting building, Corder House, is encrusted with terracotta ornament, producing a fierce red colour and a riot of inventive detail. Gothic and baroque elements vie for attention, and the resulting effect is a bizarre mutation of styles that few other architects would have attempted. The façade divides itself into two projecting bay windows that culminate in Dutch gables. The windows have the fluid form typical of baroque architecture, but in a highly eclectic touch, they are framed by Gothic pilasters and foliage. A balcony juts out at second-floor level, displaying shields, Gothic lettering and swooping doves. The twin gables are pierced by oval lights, and a Gothic turret rises between them to crown the structure.

Both buildings derive their colour and rich detail from the use of terracotta, a material that became popular in the 1890s because it was relatively cheap and resistant to atmospheric pollution. In both cases the terracotta was made by James Coster Edwards (1828–96), who founded his workshop _c._ 1856 at Ruabon, North Wales. He opened additional works in the 1880s and by the end of the century was the largest terracotta manufacturer in the world, employing renowned designers such as Lewis F. Day (1845–1910). Both buildings project a

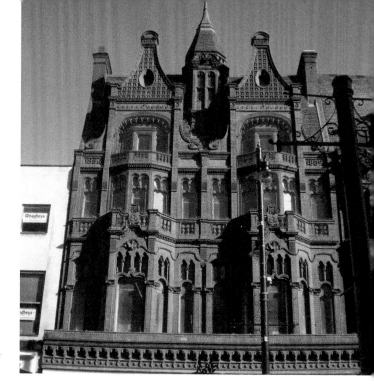

Figure 40. The terracotta façade of Corder House.

strong sense of corporate identity through the use of architectural lettering. Edwards' name is written on the façade in a permanent tribute, along with the names of the architect and the contractors, David and John Rankin.

26. Sydenham House

Sydenham House is the equal of its neighbour on Fawcett Street. The façade is dominated by a central bay window that surges through the upper storeys and culminates with a segmental pediment displaying the name of the building. In another strange fusion of styles, the crowning gable recalls Renaissance architecture, but incorporates an arched window with sinuous Gothic tracery. A griffin is perched on the keystone of the window, spreading its wings defiantly. The first-floor windows are framed by pilasters of sparkling grey granite and their heads are curvilinear in form, anticipating art nouveau design from Europe.

Corder House and Sydenham House were the first Ruabon terracotta façades in Sunderland. Caws produced drawings for every brick and tile, which were then made by Edwards and transported to Sunderland for on-site assembly. The fact that all components fitted perfectly is a testament to the skill of both parties. To prevent further fires, both buildings have fireproof concrete flooring, provided by Grimshaw of South Hylton, and no timber was used in their construction. This demonstrates that, despite his apparent eccentricity, Caws was a technically-minded architect.[32] He kept his own office in Sydenham House, which suggests that he was proud of the design.[33]

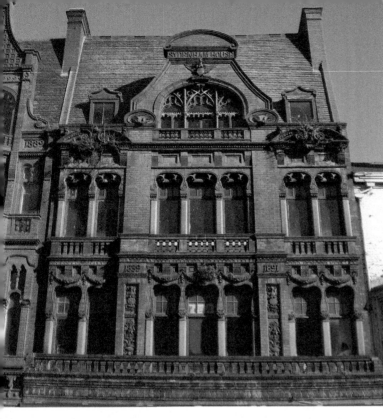

Left: Figure 41. Sydenham House was best known as Meng's restaurant.

Below: Figure 42. Terracotta detail at Sydenham House.

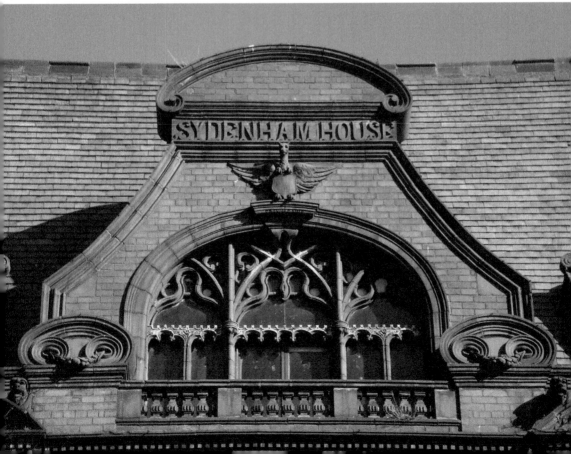

27. Langham Tower

Domestic architecture in Sunderland ranges from the luxurious mansions of Victorian industrialists to the humble cottages of the town's workforce. The wealthiest built prestigious houses in the exclusive suburb of Ashbrooke. Langham Tower (1886–91) was built by the successful merchant William Adamson and designed by William Milburn (1858–1935), who became one of Sunderland's most prominent architects. This was Milburn's first major commission and he clearly enjoyed the freedom of a £5,000 budget and a client who wanted his house to make a statement. Victorian capitalists frequently used neo-medieval architecture and heraldic imagery to portray themselves as men of taste and breeding, rather than *nouveau riche* upstarts, and Langham Tower exemplifies this tendency.

The Tudor-Gothic design closely follows the model of Cragside (1870–85), the romantic country mansion built by Lord Armstrong (1810–1900) near Rothbury in Northumberland. This was part of a movement known as the English Domestic Revival, in which architects such as Richard Norman Shaw (1831–1912) invoked the legacy of English domestic architecture by reviving quintessentially homely styles such as Tudor and Queen Anne. A suburban imitation of Cragside, Langham Tower reveals the same urge to escape from industrial bleakness into romantic medievalism.

The main bulk is executed in red brick and abounds with half-timbered gables inspired by the houses of the Tudor period. A tower thrusts out at the west, ensuring that the house has a commanding presence on Ryhope Road. The tower ends with mock battlements and a diminutive, but fully formed gable. This is a direct quotation from Cragside, but also functioned as an observatory for Adamson to watch ships returning from trading posts. A colossal chimney of moulded brick is built alongside and features a terracotta panel depicting a lion in profile and Adamson's family motto, '*Semper Paratus*' – 'Always Prepared.'

The wide garden frontage to the south has three projecting bays of varying form, culminating in an octagonal bay crowned with a short spire and battlements. Hunting motifs proliferate, including the heads of wild boars and lions that project from the eaves. These elements are all within the Tudor-Gothic tradition, but the red-brick execution and extensive use of terracotta suggest an awareness of the burgeoning Queen Anne movement, particularly the potted sunflower motif on the exterior. Thus, the house encapsulates two of the main stylistic impulses within late Victorian domestic architecture.

The interior unfolds in a series of views that proclaim the wealth and status of the owner. The entrance porch is framed by a rich Tudor arch carved with strikingly naturalistic leaf and animal forms. Beyond, the opulent interior is lined with rich wood panelling. A staircase rises around three sides, and at the foot stands a bronze statue of an armoured warrior brandishing a gas-lit torch. Dominating the hall is perhaps the finest secular stained-glass window in Sunderland. Executed by Atkinson Brothers of Newcastle, it features twelve radiant panels celebrating the technological and cultural achievements of Victorian Britain.

Adjoining the hall is the dining room, a large chamber with a lustrous ceiling of pressed paper and copper. The room is dominated by an inglenook fireplace inspired by the famous example at Cragside. It is flanked by stained-glass panels depicting medieval knights, which are clearly inspired by the Morris & Co. glass inside Armstrong's house. The fireplace is framed with hunting scenes to evoke aristocratic rural pursuits.

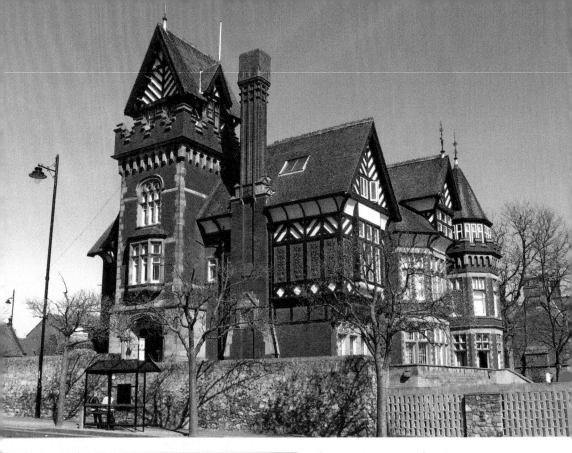

Above: Figure 43. Langham Tower is a suburban imitation of Cragside.

Left: Figure 44. Detail of the stained-glass window.

Langham Tower was not long used as a house as it required too many servants to function comfortably and after 1919 it became Sunderland Teacher Training College.[34] It was owned by the university, then Sunderland High School. The school closed in 2015 and the building's future is uncertain.

28. Technical College

Sunderland's most prestigious educational institution was the technical college in Green Terrace (1899–1901), which provided instruction in science, engineering and naval architecture, disciplines that were much needed in a shipbuilding town. The college was built with funds designated for technical education by the Local Taxation (Customs and Excise) Act of 1890.[35]

Figure 45. The decorous façade of the former technical college.
Figure 46. *Inset*: Terracotta emblem representing mechanical engineering.

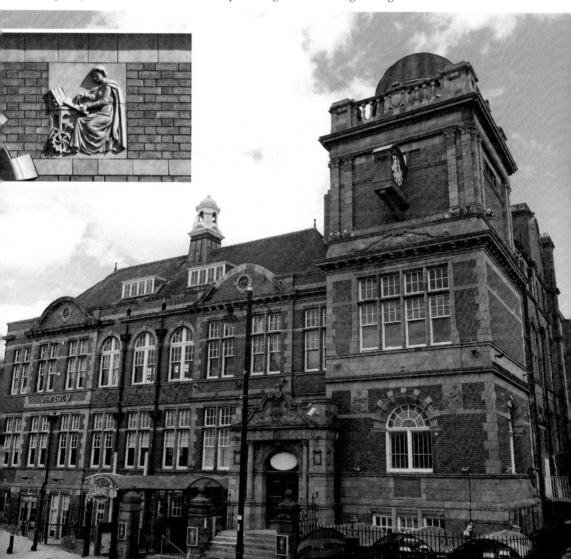

The college was built in 1899, after a competition that was judged by the eminent architect J. M. Brydon (1840–1901). None of the premiated designs were by local practitioners. The winner was the firm of Potts, Son and Hennings of Manchester and London, who had made their reputation designing cotton mills. A. W. Hennings (c. 1857–1926) was now in charge of the firm and was eager to move the practice into new areas.

The grand façade was designed in a free English Renaissance style, bristling with terracotta detail. The porch has a swan-necked pediment with vivid nautical symbolism. Figures of mermaids brandish the arms of Sunderland Borough and a globe indicates that the college trained pupils for careers as seafarers and marine engineers. Allegorical representations of chemistry and mechanical engineering testify to other subjects taught at the college. All of these details were made by the Hathern Station Bank and Terracotta Co. near Loughborough. A stolid but decorous tower rises at the corner and the structure is crowned by the dome of an observatory for teaching nautical astronomy.

With its fiery colour, the college resembles the red-brick board schools of the era, but is much richer in execution. As with many public buildings of the period, the florid ornament masks a rigorous structure of fireproof concrete flooring. The laboratories had high ceilings to allow air to circulate and the wide corridors and stairways were lined with tiles for easy cleaning. In recent years the building has operated as a bar.

29. Dun Cow

The Dun Cow (1901–02) is among the finest public houses in Sunderland. A pub had stood on this site for generations, but the enterprising owner Robert Deuchar employed the talented, if eccentric, Newcastle architect Benjamin Simpson (1860–1940) to design an eye-catching replacement. The result is a splendid Edwardian gin palace with lavish interiors of cut glass and polished wood.[36]

Rising from a plinth of grey granite, the elevations have the plasticity characteristic of Edwardian baroque architecture, full of movement, drama and imaginative detail. Polished shafts of black marble rise from the plinth to support segmental pediments over the doors. Shallow bay windows project from the first floor, and the upper windows are linked by block rustication. A turret juts out from the corner and culminates in a copper dome. Simpson used similar whimsical turrets in his designs for Emerson Chambers (1903) and the Corporation Tramways building (1900–04) in Newcastle. The building terminates with decorous Dutch gables and tall chimneys decorated with Deuchar's initials.

The interior is well preserved, consisting of two rooms divided by an undulating wooden screen with luminous stained-glass panels. Its serpentine form and decorative flair demonstrate that Simpson was enamoured of the art nouveau style that emerged during this period. The crowning glory of the interior is a decorative screen behind the bar, which fuses oriental and Gothic motifs into something resembling a theatrical stage set. The Indo-Gothic design echoes the Elephant Tea Rooms on Fawcett Street. Overall, the Dun Cow is a baroque extravaganza that forms a fitting counterpart to the neighbouring Empire Theatre (1907).

Figure 47. The Dun Cow is a splendid Edwardian drinking palace.

30. Londonderry Arms

The Londonderry Arms (1901–02) is another fine example of the luxurious public houses built across Sunderland at the turn of the century. Erected by the Newcastle brewers Duncan and Daglish, this charming Edwardian pub occupies a triangular site on High Street West, which had previously been occupied by a pub called the Sign of the Peacock. The new building was required to be in keeping with the proposed court and fire station nearby, and it was designed in a tasteful Jacobean style that complements the Edwardian baroque architecture of this vicinity.

The irregular site was the result of a traffic management scheme and placed severe constraints on the architect, Hugh Taylor Decimus Hedley (1866–1939), who earned the splendid name Decimus by virtue of being his parents' tenth child. Hedley's solution was to create a triangular design with circular turrets to round off the sharp corners. The turrets are capped with ogee domes and spike finials. The principal façade has an entrance set within a rusticated arch and the delicate oriel window above defines the building's Jacobean character.

The south elevation has a vehicle entrance cut into the façade and the architect evidently tried to mitigate this disruptive feature by setting it within a segmental arch matching those of the windows. The most unusual feature occurs at the south-east corner, where, instead of a turret, a porch is formed beneath the overhanging first floor, supported on a single column of granite. Inevitably, the pub has a triangular interior, which enabled three saloons to be served by one bar.

Figure 48. The Londonderry exemplifies Sunderland's rich turn-of-the-century pubs.

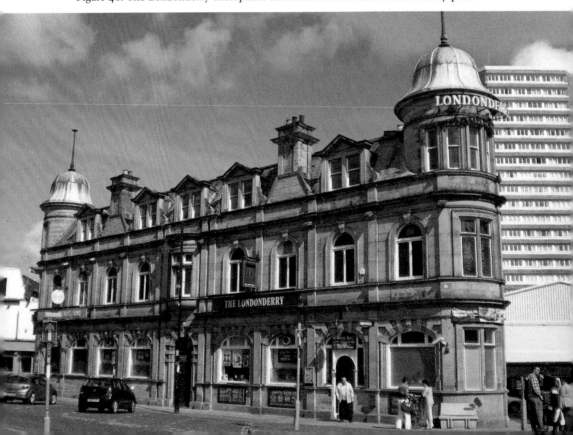

31. Mountain Daisy

The Mountain Daisy in Hylton Road (1901–02) is a splendid Edwardian public house. A pub already existed on this site, but in 1900 the owner, W. B. Reid, hired the versatile local architects William and Thomas Ridley Milburn (1862–1943) to design a veritable drinking palace to compete with the spectacular new pubs being erected throughout the town.

The Mountain Daisy is the Milburn brothers' finest surviving pub. The robust design uses the Queen Anne style, which was loosely based on the architecture that flourished during the reign of Queen Anne (1702–14). The bulk is executed in red brick and sandstone, but the ground floor is lined with polished black marble to protect it from wear and tear. A stolid square tower stands at the corner and shaped gables add visual interest to the roofline. The name of the pub is proclaimed by a bronze plaque on the west face depicting a mountain daisy flower.

Imposing as the exterior is, the real beauty lies within. Originally there was a long front bar, with two smaller sitting rooms and a newsroom at the rear, all decorated with lavish tile work. The original design scheme is preserved in the buffet room, which has a quarter-circle bar lined with yellow and green faïence, a form of glazed earthenware. The walls too are lined from floor to ceiling with faïence tiles, the hard, lustrous surfaces combining with a mosaic floor and rich woodwork to create a suitably intoxicating effect.

Figure 49. The Mountain Daisy is the finest pub by the Milburns.

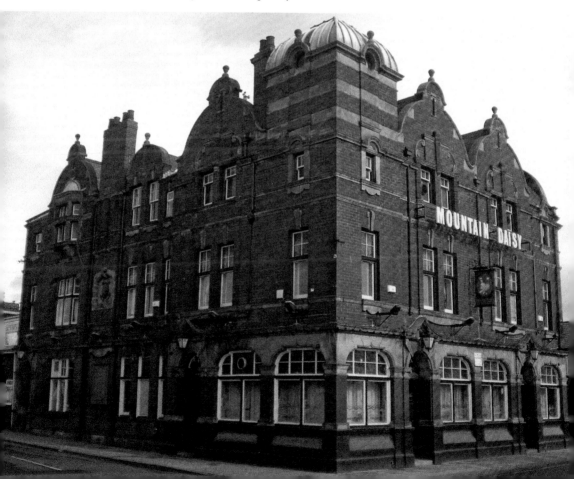

In the late nineteenth century, a number of ceramics manufacturers began to offer mass-produced decorative tiles, terracotta and faïence, which were sold through catalogues. The Mountain Daisy's tiles were supplied by the firm of Craven, Dunnill and Co., founded in 1871 near Ironbridge in Shropshire. The firm was also responsible for the peerless tile work inside Manchester Town Hall (1868–77). Although the tiles were mass-produced, the Mountain Daisy has a unique decorative scheme because many of the tiles were painted with historic scenes of County Durham and Northumberland, including Bamburgh Castle, Cragside, Marsden Rock and the bridges of Sunderland and Newcastle.

The interior also boasts stained glass depicting scenes of merriment. There is a large function room upstairs, retaining old bar fittings, a tiled fireplace and further stained glass.[37] The Mountain Daisy survives as one of many opulent pubs built at the turn of the century, which served as important social sites for the town's workforce. Sadly, these glorious drinking dens are becoming rare as their interiors are modernised and others are closed altogether.

32. Sunniside Chambers

Commercial enterprises were flourishing in Victorian Sunderland and this necessitated the building of offices to provide business premises. Towards the end of the century, full-scale office blocks were being built on a speculative basis for rental, while others were purpose-built by individual companies. Among the most interesting buildings of this type is

Figure 50. Sunniside Chambers introduced art nouveau architecture to Sunderland.

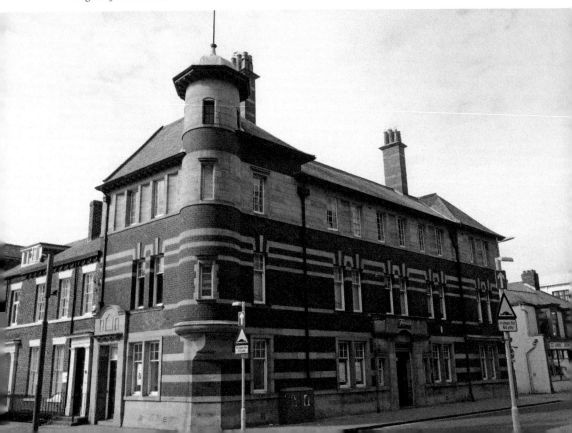

Sunniside Chambers in West Sunniside (1900–02). Built by the firm of Botterell & Roche, maritime solicitors, this is a three-storey office block in a freely treated baroque style. It was designed by the local architects Henderson and Hall, who specialised in office design. They were also responsible for the neighbouring Maritime Buildings (1900) and the delightful River Wear commissioners' office on St Thomas Street (1904–07).

Sunniside Chambers shows the unmistakable influence of Richard Norman Shaw's famous designs for Scotland Yard in London (1887–1906), featuring a similar corner turret and a vibrant colour scheme based on contrasting bands of brick and sandstone. By the turn of the century, the baroque style was being used in a very free manner and, together with the emergence of art nouveau, this encouraged more fluid architectural forms. Sunniside Chambers is a product of this increasingly abstract approach, with concave panels receding into the walls and a turret that tapers as it rises. Carved foliage around the doorway exemplifies art nouveau's exaggerated natural motifs.

33. Police Station and Magistrates' Court

The edifice that crowns Gill Bridge Avenue was Sunderland's largest municipal building project of the early twentieth century. Built by the Corporation as a police station and magistrates' court (1905–07), the building has the baroque flair typical of the period, but as a judicial institution, many of its features are stern and monumental. The design was the result of a 1902 competition that failed to attract many distinguished architects. The nominal winners were Wills and Anderson of London, who specialised in such buildings. In practice, however, the construction was overseen by Sunderland's pre-eminent architects of the Edwardian era, W. and T. R. Milburn.

Figure 51. The Police Station and Magistrates' Court was conceived as a beacon of justice.

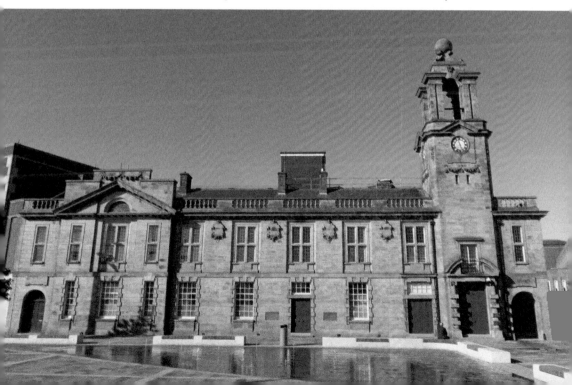

The asymmetrical composition was shaped by the irregular site, but the broad façade is balanced by a pedimented pavilion at one end and a strident tower at the other. The tower is monumental, with a lantern of square columns supporting a stone sphere. Standing as a symbolic beacon of justice, it recalls ancient lighthouses such as the Tower of Hercules in La Coruña, Spain.

Baroque ornament enriches the façade. The lower windows are emphasised with block rustication and interspersed between rich cartouches. The entrance is an elaborate frontispiece set at the base of the tower and fortified with a Gibbs surround, a detail named after the baroque architect James Gibbs (1682–1754), consisting of stone blocks pierced by columns. Above this is a broken pediment and a barred window, suggesting, *sotto voce*, the threat of incarceration.

Behind the principal façade, the design of the cell block was appropriately austere. In a bold gesture, the north elevation has arcing Diocletian windows, a motif derived from the giant bathhouses of Ancient Rome and commonly seen in neoclassical architecture. Despite its shortcomings, the building represents a grand finale to the approach along High Street.[38] The recently regenerated Keel Square has created a new urban setting that shows off the building to best effect.

34. Empire Theatre

The Edwardian period (1901–10) can be seen as the climax to Sunderland's century of urban development. Public buildings, office blocks and places of entertainment were designed in the grandiloquent baroque style as a display of civic pride. Together these buildings crystallised Sunderland's architectural identity at the start of the twentieth century.

The pinnacle of Sunderland's Edwardian renaissance is the Empire Theatre (1907) in High Street West. This baroque palace was the first of thirty-seven theatres designed by W. and T. R. Milburn for the national Moss Empire chain. Thanks to this connection, the Milburns were the only Sunderland architects to have a reputation beyond the North East, and the grandest commission they won was for the Dominion Theatre in London (1928–29).

The centrepiece is a cylindrical tower adorned with lions' heads and festoons of flowers. The structure is crowned with a copper dome, where a cluster of Ionic columns supports a globe. A graceful statue of Terpsichore, the Greek muse of dance and choral song, originally stood at the summit, brandishing a laurel leaf. Sadly, the figure had to be removed due to weather damage in 2014 and is currently stored inside the building. Another treasure within the vault is a bust of Shakespeare, which is all that survives of the Theatre Royal on Bedford Street (1855).

This decorous façade exemplifies the baroque tendency to synthesise architecture and sculpture into overpowering compositions. It was this quality that made it the optimum style for theatre design. Such buildings required the audience to suspend disbelief and surrender themselves to the realm of fantasy, and this process was facilitated by baroque confections of masonry, woodwork and plaster.

The theatre is entered through a porch in the base of the tower, framed by mahogany columns. Inside, the vestibule houses a remarkable series of oil paintings depicting the

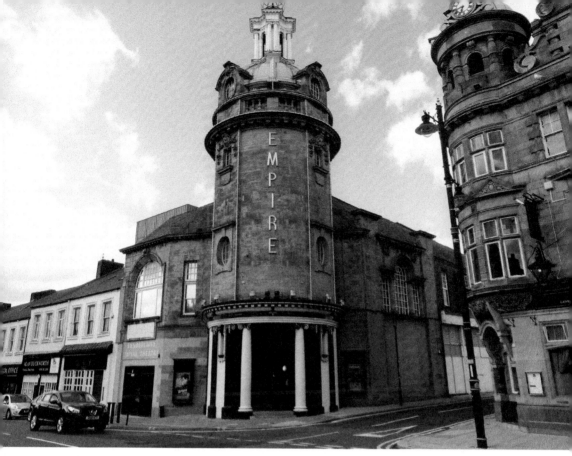

Figure 52. The Empire Theatre was the climax of Sunderland's Edwardian renaissance.

cultural luminaries Shakespeare, Mozart and Beethoven. The main staircase rises in a grand curve to the palatial auditorium, with three sweeping balconies embellished with plaster decoration. Beneath this lavish surface, the cantilevered floors and staircases were built of concrete in an effort to make the building fireproof.[39] The Empire Theatre has been much altered and extended over the years, but remains one of Sunderland's best-loved buildings.

35. Hawksley House

As Victorian Sunderland expanded in scale and complexity it required a vast infrastructure to provide utilities such as water and gas for its inhabitants. The Sunderland and South Shields Water Company was founded in 1852 and used the renowned water engineer Thomas Hawksley (1807–1903) to design twelve pumping stations between 1846 and 1905. Ironically, the one Water Company building Hawksley did not design is the one now named after him, the head office in John Street (1907). The architects were W. and T. R. Milburn, whose best-known building, the Empire Theatre, was completed in the same year.[40]

The edifice was executed in red sandstone from Penrith, which gives the building a lush colour unusual in Sunderland. The design follows the model of Italian Renaissance '*palazzi*'

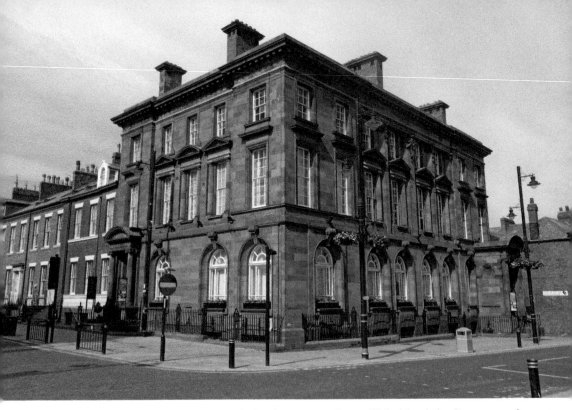

Figure 53. Hawksley House is named after the engineer who established Sunderland's water supply.

or town palaces that served as both business premises and urban residences for mercantile families such as the Medici. This model was frequently used for Victorian bank buildings because it enabled architects to combine a public banking hall on the ground floor with private office space above, all enclosed within a dignified façade. The banks on Fawcett Street exemplify this type. By the time the Water Company offices were built, however, the Italian Renaissance style would have seemed rather old fashioned. Recognising this, the Milburns adapted the palazzo model to contemporary Edwardian tastes by incorporating fashionable baroque elements such as delicate chamfered pilasters and ornate shield-like emblems known as cartouches.

Surplus to requirements after the formation of Northumbrian Water, the building stood empty for a number of years. However, it has now found a new role as apartments, one of a number of such refurbishments of historic buildings undertaken by the local social housing company, Gentoo.

36. River Wear Commissioners' Building

Among Sunderland's most important public bodies was the River Wear Commission, which was founded in 1717. The commissioners played a vital role in the town's development, providing much of the infrastructure that allowed shipbuilding and trade to flourish. During their long history, the commissioners occupied premises in various buildings, including Sunderland Exchange, and it is surprising that such an illustrious body had no

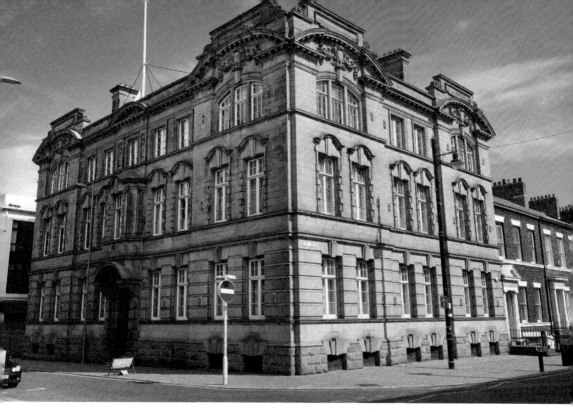

Figure 54. The elegant River Wear Commissioners' Building.

Figure 55. Boardroom of the River Wear Commissioners' Building.

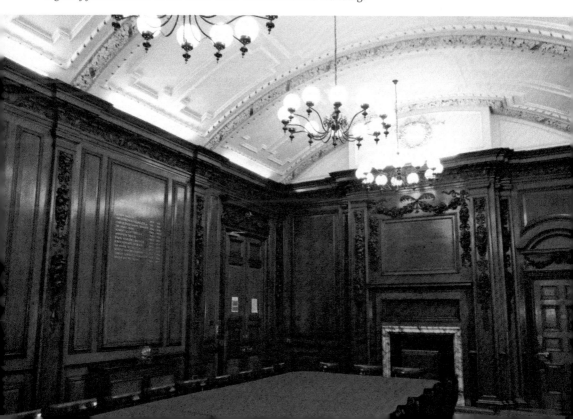

building of its own. This was rectified in 1904–07, when a dedicated office was built on St Thomas Street. The resulting building is one of the most graceful structures in the city.

The design reflects the vogue for the grandiose Edwardian baroque style, but it is designed with an elegance that surpasses its contemporaries. The building stands on a plinth of rock-faced pink granite from the Corrennie quarry in Aberdeenshire, making a bold statement of strength. Rising from this rugged base, the elevations are graced with rich decoration in blue-tinged stone from Heworth Burn, carved by H. H. Martyn & Co. of Cheltenham and Newcastle. Punctuating the composition, the outer pavilions are crowned with curved pediments of exceptional delicacy. An exquisite oriel window emerges from the centre of the façade.

The entrance is framed with a Gibbs surround, with columns and jutting blocks of stone. Signalling the importance of Sunderland's maritime industries, the image of a sextant is emblazoned above the doorway. By maintaining the town's port facilities, the River Wear Commissioners opened Sunderland to international commerce. Accordingly, the building uses a range of exotic materials from around the world. Three separate varieties of stone were employed in the vestibule alone, namely Skyros and Bleu Belge marbles and Verde Antico, as well as translucent alabaster.

The interior houses a suite of stately rooms and all fittings were designed by John Hall (1869–1935), who was the partner in charge of the project. The central hall is lit by a glazed oculus set within a coffered dome and the walls are lined with gleaming panels of Austrian oak. The commissioners met in the board room, a large chamber bounded by stately fireplaces. Superb woodwork by James Garvie & Sons of Aberdeen was carved from expensive Cuban mahogany and lime wood in the style of Grinling Gibbons (1648–1721), a talented sculptor and woodcarver who worked at St Paul's Cathedral and Blenheim Palace.

The brilliance of the design and the use of exquisite materials emphasise the fact that the River Wear Commissioners transformed Sunderland into a gateway to the world economy. As stated in the *Sunderland Year Book* of 1907, 'No expense was spared in order to make the building thoroughly worthy of the important body at whose instigation it was erected.'[41]

37. St Andrew's Church, Roker

The crowning glory of Sunderland architecture is St Andrew's Church at Roker (1904–07). With its superb architecture and fittings, St Andrew's is internationally renowned as the 'Cathedral of the Arts and Crafts Movement'. Designed by first-rate architect Edward Prior (1852–1932), the church is built of reinforced concrete, but clad in rugged local stone and this produces a building of incredible expressive power.

The population of Roker was growing after the turn of the century and a committee of Roker and Fulwell residents was formed in 1903 to campaign for a new church. The local shipbuilder John Priestman offered £6,000 for the construction of a church to serve as a memorial to his mother, provided that a further £3,000 could be raised by public subscription. He also selected the architect and the dedication to St Andrew. The church was built at a cost of £9,378.

Prior was educated at Harrow and Cambridge, before training in the office of Richard Norman Shaw, one of the most celebrated architects of his generation. Prior was aligned

with the Arts and Crafts movement, which aimed to challenge the effects of industrialisation by reviving traditional craft skills and pre-industrial modes of life. He was a member of the Art Workers' Guild and the Arts and Crafts Exhibition Society. Prior was also a noted academic, well known for his scholarly books on medieval art and architecture.

St Andrew's Church stands upon rugged cliffs and its stolid tower was placed at the east end to form a landmark for sailors. Nevertheless, the chancel punches through the tower and obtrudes at the east. This restless interlocking of forms is typical of Prior's work and earned him the epithet 'rogue-architect' from the critic H. S. Goodhart-Rendell, whose article 'Rogue Architects of the Victorian Era' (1953) described Prior as 'recklessly inventive and crushingly insensitive.'[42]

Arts and Crafts designers were committed to the honest use of materials. The local building stone of the area is a magnesian limestone that is very coarse in texture and unsuitable for decorative detail. Faced with this material, most architects would have used imported stone, but Prior recognised that this was the fabric from which Sunderland's vernacular architecture was built and designed the church accordingly. The forms are deliberately crude and rugged, extolling the inherent properties of the stone. This gives the building a symbolic connection to the locality; it is made from the very substance of the rugged coast on which it stands. In selecting the stone, Prior avoided the mechanised quarry at Fulwell in favour of a more distant quarry at Marsden, which was still 'worked by quarrymen with their usual tool – the scutcher, a broad bladed pickaxe.'[43]

Figure 56. St Andrew's Church is an Arts and Crafts masterpiece.

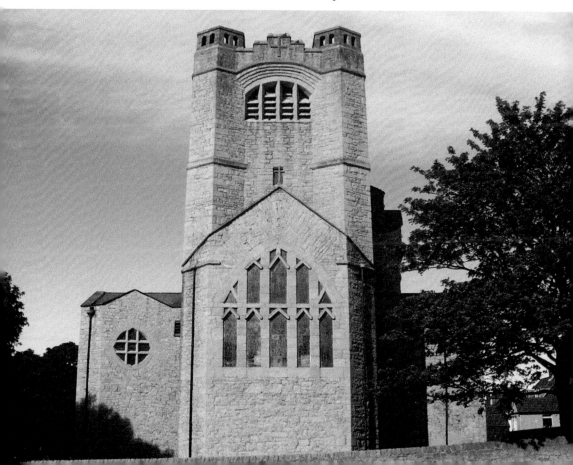

Inside, a cavernous nave is formed beneath massive transverse arches. The colossal space resembles a primeval cave, though some have noted a similarity to the upturned hull of a ship. The arches are abruptly cut off at head height and rest upon pairs of short hexagonal pillars, creating tunnel-like passages beneath them. This innovative plan met Priestman's requirement that everyone should have a clear view of the altar. In the windows, delicate Gothic tracery is replaced with brutally angular forms resembling the cross of St Andrew. The glass was made by hand to Prior's own recipe and shaped in clay moulds. The small panes throw scintillating light across the stonework and emphasise its coarse texture.

Beneath the rugged stonework, the church conceals an innovative structure of reinforced concrete. Iron rods run down through the arches and into the ground, while exposed concrete purlins run along the roof. To achieve this structure, Prior enlisted the skills of Albert Randall Wells (1877–1942), an expert in concrete construction. The use of reinforced concrete may seem incompatible with the Arts and Crafts principle of truth-to-materials, but Prior saw no contradiction. To his mind, reinforced concrete was 'only the simple straight forward elementary science of building.'[44] Nevertheless, Wells felt obliged to justify the use of concrete by writing:

> Rough stonework in any masses implies a core. The inference in these days would naturally be a cement concrete core. In heavy arches in which economy has been effected by constructing them not of worked voussoirs, but of roughly-dressed quoins and wall stones . . . it should be apparent that advantage has been taken of the one important modern addition to building materials, i.e. reinforced concrete.[45]

The church was built in a collaborative spirit that grew out of Prior's dissatisfaction with the state of contemporary architecture. Like many Arts and Crafts practitioners, Prior believed that the professional system had severed design from the healthy influence of craftsmanship. In place of professional architects, Prior wished to instate a 'designer-builder' who would not himself design, but would only 'quarry the best stone, make the best brick, forge the best iron.'[46] The presence of Randall Wells was an attempt to achieve this ideal. Prior produced the designs, but Wells acted as resident architect and refined the details on site.

Leading members of the Arts and Crafts movement contributed fittings. The sculptor and typographer Eric Gill (1882–1940) created dedication panels with beautifully executed lettering. The furniture designer Ernest Gimson (1864–1919) made the exquisite lectern with mother of pearl and silver inlay, together with crosses and candlesticks of wrought iron. William Morris, the leader of the Arts and Crafts movement, designed the chancel carpet, which was coloured with vegetable dyes, rather than the harsh chemical dyes typical of the period. Ada Louise Powell (1865–1956) created an altar frontal in the style of Morris. The Pre-Raphaelite painter Sir Edward Burne-Jones (1833–98) designed the tapestry that serves as a reredos. His typically somnolent design is based on the artist's *Star of Bethlehem* (1897) and was executed in Morris' workshop at Merton Abbey.

After the starkness of the nave, the chancel bursts with colour in the form of a mural designed by Prior in 1927 and executed by Leslie MacDonald Gill (1884–1947), brother of Eric. This is a pictorial retelling of Genesis and the forms radiate from a central globe of alabaster representing the sun.[47] Prior's design is simply a series of labels denoting specific images such as the 'creator enthroned' or 'trees and fruit' amid the architectural

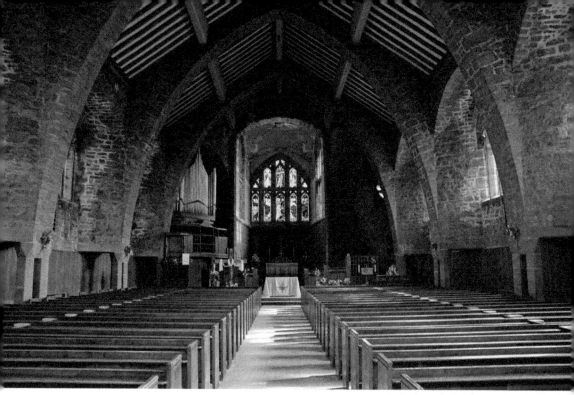

Above: Figure 57. The cavernous nave was built with reinforced concrete.

Right: Figure 58. Chancel mural by MacDonald Gill.

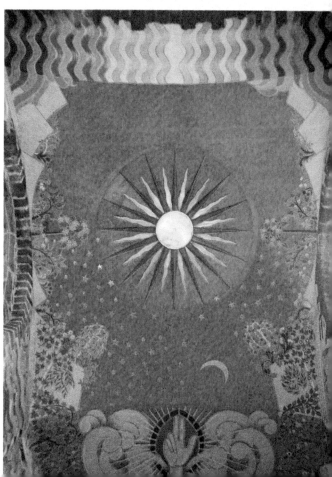

lines. Within the structural framework, Prior has orchestrated the elements into an artistic conception, but the individual forms are left to Gill's interpretation. This is an appropriate metaphor for Prior's role in the overall design of the church.

Together, the church and its fittings express the theme of redemption through work. The rough-hewn nave is transcended by the splendour of the chancel: the implication is that heavy labour is rewarded in Heaven. Stained-glass windows by Henry Payne (1868–1940) reinforce this theme, bearing the inscription, 'Come unto Me all ye that labour and I will give you rest.' Of course, this was a message that held deep meaning for a hardworking industrial parish.

Overall, St Andrew's is a superb example of Arts and Crafts architecture and a triumph of the art of building. To achieve this, Prior devised an unconventional building process that surpassed the formulaic architecture of his contemporaries. By combining enthusiasm for tradition with the new technology of reinforced concrete, he created an exceptional building with a breathtaking internal space.

38. St Joseph's RC Church, Millfield

At first glance, St Joseph's RC Church in Millfield appears to be a conventional small parish church in a working-class district. In fact, this is a unique structure in Sunderland because it was a pioneering example of concrete construction.

The parish was established when Canon John Bamber of St Mary's Church in Bridge Street bought land in King's Place and built a school chapel at a cost of £2,000 (1871–73). The church was built in 1906–07 at a cost of only £3,600. Serving an industrial district, it was dedicated to St Joseph, 'the patron of the artisan and the horny-handed labourer'.[48]

The parish priest, Father John Rogers, helped to plan the church, but it was built according to an experimental process developed by Thomas Axtell (d. 1909) of Ryhope, who was credited as architect. Axtell had previously been clerk of works for the building of an extension to Ryhope Asylum and was a founding member of the Concrete Institute in 1908. He supervised the manufacture of the concrete blocks, which were made on site and moulded to fit their required location in the building. The internal columns were cast solid.[49] A contemporary newspaper reported:

> By reason of the class of material used in its erection, it marks a new departure in the construction of ecclesiastical edifices. Instead of stone or bricks being utilised in its construction the church is built of concrete blocks. This is an American system and its adoption in the present instance is due to Mr Thos. Axtell ... The first cement block EVER MADE IN THE WORLD FOR A CHURCH was made on Friday, 4th May, 1906 by the Rev. Rogers and Joseph Kinleside and is placed about the chancel arch.[50]

Given that the Victorians tended to 'beautify' structures by embellishing them with historicist ornament, it is surprising that no plastering was used within the building. Instead, the raw concrete was left exposed. This anticipated the rationalist architecture of the twentieth century, which emphasised structural integrity. St Joseph's makes an interesting comparison with the more celebrated church of St Andrew at Roker, which was completed in the same year. St Andrew's was built of reinforced concrete, but clad in rough

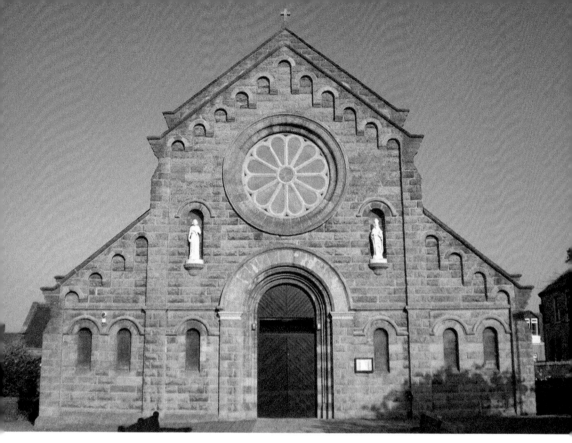

Figure 59. St Joseph's Church was a pioneering structure.

local stone. In this sense, St Joseph's is a more honest building, with no attempt to disguise the method of construction.

Perhaps influentially, J. F. Bentley (1839–1902) had told Axtell of the effective use he had made of concrete in the domes of Westminster RC Cathedral in London (1895–1903). Contemporary with St Joseph's, Axtell built an almost identical church at Seaham Harbour, dedicated to St Mary Magdalen (1907) and it seems that his death prevented further experiments in this vein.

If the construction method was daringly modern, the aesthetic was drawn from the distant past. St Joseph's was designed in a Romanesque basilican style, with round-headed arches and a semicircular apse to house the sanctuary. Externally, the blocks were moulded to resemble rock-faced stone, emphasising the archaic power of Romanesque architecture.

39. St Gabriel's Church

St Gabriel's Church at High Barnes (1912) is one of the finest twentieth-century buildings in Sunderland. A highly inventive design by Sunderland's only Arts and Crafts architect, the church is a striking synthesis of Tudor and art nouveau styles.

The affluent suburb of High Barnes had been served by a temporary corrugated-iron church (1898) and a stone mission church (1901) before the parish of St Gabriel was

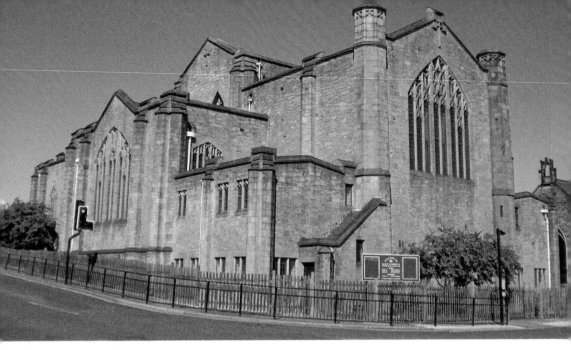

Above: Figure 60. St Gabriel's Church is a synthesis of art nouveau and Tudor styles.

Below: Figure 61. The unbuilt tower and spire of St Gabriel's.

created in 1904. A fund was instituted for the building of a larger church and this led to a competition in 1908 that was judged by W. D. Caröe, the architect who would later rebuild St Michael's Church, Bishopwearmouth. The competition was won by C. A. Clayton Greene, a Sunderland architect whose work reveals an affinity for the Arts and Crafts movement.[51]

The Gothic Revival that had been so dominant in the nineteenth century continued into the twentieth, but became notably less dogmatic in character. Some architects interpreted the style in new ways, even tending towards abstraction. With its unconventional massing and disparate influences, St Gabriel's illustrates this transition and embodies the progressive instincts of its architect.

The nave is both tall and wide, with transepts cutting across the midpoint to form a cross. Elaborating this form, the angles between nave and transepts are occupied by chapels, giving the church a T-shaped plan. The high crossing was intended to support a tower, but this was never built due to lack of funds. Greene used the slope of the ground to incorporate an undercroft beneath the east end, containing a hall and classrooms.

The style may be understood as an art nouveau interpretation of the Tudor Gothic style. This is apparent from the great east window, which is framed by octagonal turrets with Tudor ornament, while the window itself is a majestic display of curvilinear art nouveau tracery. Amid the flowing lines, Greene incorporated the Ichthus symbol used by early Christians, an ingenious way of giving the avant-garde design a deeper spiritual meaning. Greene had travelled in Belgium, where he would have encountered examples of art nouveau architecture by leading practitioners such as Victor Horta (1861–1947). Overall, the design of St Gabriel's is indicative of architecture outgrowing revivalism and anticipating the more abstract designs of the twentieth century.

Inside, the aisles are reduced to narrow passages to provide clear views of the altar. This layout was probably influenced by Edward Prior's design for St Andrew's Church, Roker (1907). Square piers at the crossing of the nave and transepts were built to support the proposed tower. In 1912, Greene published a book entitled *Churches and their Building*, which advocated Gothic as the most suitable style for Anglican churches. However, the book also explored alternative models, such as the central-plan churches and mosques of Constantinople, where four piers around a central space support an overhead dome, and the internal planning of St Gabriel's may have been informed by this source. As part of his brilliantly unified conception, Greene designed woodwork within the church, including a superb pulpit and lectern.

4C. Hammerton Hall

Hammerton Hall in Gray Road (1914) is an Arts and Crafts villa in leafy Ashbrooke. The house was designed by the talented local architect C. A. Clayton Greene and is the strongest display of his Arts and Crafts credentials. Born in London, Greene was articled to Benjamin Simpson of Newcastle. Domestic architecture was a strong focus of his work, and in this field he was influenced by Sir Edwin Lutyens (1869–1944), whom he greatly admired.

Hammerton Hall was inspired by Edgar Wood's design for Upmeads in Stafford (1906). Both houses feature a concave façade and a vertical strip of masonry to emphasise the entrance. The whole design has the robust simplicity of Arts and Crafts buildings, with thick stone mullions to the windows, brick chimney blocks and an expressive porch of curved wooden beams.

Figure 62. Hammerton Hall is a charming Arts and Crafts villa.

Unlike Upmeads, the outer wings are built at right angles to each other. In this respect, Hammerton Hall was probably influenced by The Barn (1896), a seaside house in Exmouth, Devon, designed by Edward Prior. This house was built on a butterfly plan, with the wings embracing the entrance courtyard to form a suntrap. The Barn featured in Hermann Muthesius' study of English domestic architecture, *Das Englische Haus* (1904), and had considerable influence. Hammerton Hall is, therefore, an amalgam of two of the most advanced domestic buildings of the period and a testament to Greene's knowledge of progressive architectural trends. The house served as a Voluntary Aided Hospital during the First World War and has since been converted into individual flats.

41. Sunderland Synagogue

The former Synagogue on Ryhope Road (1928) was a majestic place of worship for the town's Jewish community. Designed by Jewish architect Marcus Kenneth Glass of Newcastle, the building is an extraordinary fusion of Byzantine and art deco styles. A treasure of Jewish heritage, it is the only surviving synagogue by Glass and represents one of the last optimistic cultural expressions of European Jewry before the tragedy of the Holocaust.

Migrations from Holland and Germany during the eighteenth century gave Sunderland a substantial Jewish community, the oldest in the North East. Sunderland Hebrew Congregation was founded in 1791 and a burial ground was opened at Ballast Hills, Ayre's Quay. John Tillman designed a substantial synagogue on Moor Street in 1861–62 (demolished). With links to many Baltic ports, Sunderland became a haven for Jews escaping pogroms within the Russian Empire. As the Jewish population moved to wealthier parts of town after the First World War, it was decided that a new place of worship was required. A site on the Ashburn estate was purchased and the new synagogue was built at a cost of £11,000.

Historically, there was no definitive architectural style for synagogues; such buildings tended to emulate indigenous traditions in order to aid assimilation. Working in a climate of relative tolerance, however, Glass developed a unique approach to synagogue design, combining the ancient Byzantine style, which had undergone a revival in the early twentieth century, with the modern art deco style favoured for cinemas. This may seem a strange allusion for a place of worship, but Glass admired cinematic dream palaces that evoked ancient civilisations.

Figure 63. Sunderland Synagogue is a dazzling fusion of Byzantine and art deco influences.

The building is pervaded by rich symbolism. Even the original iron gates were designed in the form of a Menhora, the nine-branched candelabra lit during Hanukkah. The synagogue itself consists of a central prayer hall framed by strong octagonal towers, and the multicoloured façade is dominated by a vast window. The powerful concentric arches and luminous mosaics recall Byzantine forms, but the tracery and gleaming stained glass reveal art deco inspiration. Double doors were provided for male and female worshippers, both crowned with stained-glass fanlights.

Running below the window is a brilliant turquoise mosaic, bearing a Hebrew scripture from Numbers 24:5: '*Ma tovu ohalekha, Ya'akov, mishk'notekha, Yisra'el*' ('How goodly are thy tents, O Jacob, thy dwelling places, O Israel'). At the summit of the curved gable is a traditional Luhot, or tablet representing the Ten Commandments. In this case, the tablet is actually made of artificial stone.

The synagogue formerly housed one of Sunderland's richest interiors. The prayer hall was spanned by a barrel-vaulted ceiling, painted to resemble a star-spangled sky. Galleries were provided for women, since orthodox synagogues allocate separate spaces to male and female worshippers. These are supported on iron columns with palmate capitals. Illuminating the hall, the majestic east window features a Magen David or Star of David emblem, a symbol repeated on the gallery fronts and metal chandeliers. The east end was dominated by a magnificent gilded Aron Kodesh or Ark containing the sacred scrolls of the Torah.

Glass produced very similar designs for Jesmond Synagogue, Newcastle (1915) and Clapton Federation Synagogue, London (1931–32), but these have been altered or demolished. Sadly, the Jewish community in Sunderland has dissipated in recent years and the synagogue closed for worship in 2006. The ark, bimah and pews have been removed and the building has fallen prey to vandalism, including anti-Semitic graffiti. This has severely damaged Sunderland's most exotic interior.

42. Regal Cinema

Blacks' Regal Theatre on Holmeside (1932) was the first of five art deco cinemas built in Sunderland during the 1930s. Cinema was a form of mass entertainment that flourished during the interwar period, providing an escape from the economic hardship and political turmoil of these years. The first cinemas were converted from existing buildings, but the popularity of the 'talkies' led to the construction of more elaborate venues based on American models. The Black family was instrumental in introducing cinema to the North East, showing films in converted concert halls and chapels as early as 1906. The Regal was part of a circuit founded by Alfred Black in 1928.

Built on the site of the Olympia Exhibition Hall and Pleasuredrome (1897–1910), the flagship property could accommodate 2,522 patrons. Construction was carried out by the local builders D. & J. Ranken at a cost of £100,000.[52] The building was designed by cinema specialists Edwin Sheridan Gray and Frederick Evans of Liverpool, which suggests that, at this date, Sunderland had no architect capable of undertaking such a large and specialised commission. The firm designed many cinemas in Liverpool and Manchester, and even one in Paris.

Figure 64. Black's Regal Theatre.
(Sunderland Antiquarian Society)

The Regal was designed in the glitzy art deco style of the 1920s and 1930s. Popularised by the *Exposition Internationale des Arts Décoratifs* (1925), the style exemplified the hedonism of the Jazz Age. Art deco drew its imagery from ancient and contemporary sources and synthesised these into a vision of deluxe modernity.

The design of the Regal embodies the exotic influences that were central to the style. An ornate tower gives the building a strong presence on Holmeside, even though the street frontage is narrow. The totemic tower was lined with black and red terracotta. Much of this has since been painted over, but the original colour scheme is still visible at the rear. Obelisks rise around the tower and a serrated parapet crowns the structure, recalling Mayan temple forms. The windows are linked by a jazzy zigzag frieze. With its eclectic design, the Regal used the exoticism of the ancient world to create not so much a 'dream palace' as a 'temple of dreams.'

Specialist cinema architect Julian Leathart (1891–1967) described cinema design as a compromise between the building's architectural dignity and its role as 'a background for predetermined publicity.'[53] The façade incorporated a rectangular panel for film posters and a metallic canopy to display the names of Hollywood stars.

A vestibule with marble steps swept patrons into the long entrance hall. Beyond lay a grand auditorium with a huge proscenium arch and a riotous colour scheme. The splayed walls feature fibrous grilles in the form of dancing girls with crinoline skirts and zigzag hair, surrounded by musical notation. The compositions are set within ziggurat frames. Stylised wave motifs run around the walls, perhaps suggesting Sunderland's position on the sea.

The theatre was equipped with an illuminated Compton organ that rose up from the orchestra pit. This too was designed in the art deco style, with a ziggurat form and decorated with sunbursts. The instrument was played by the cinema's organist, J. Arnold Eagle, who inevitably came to be known as 'Eagle of the Regal', and is now preserved in Ryhope Community Centre. In 1955, the Black circuit was taken over by the Rank Organisation and the Regal was renamed the Odeon. It closed in 1982, but reopened as a bingo hall. Much of the interior has been altered, but the auditorium still gives an impression of its former grandeur.

43. Ritz Cinema

The Ritz Cinema at the end of Holmeside (1937) was another art deco dream palace of the interwar period. Built by Union Cinemas on the site of a cattle market, it had capacity for 1,700 patrons. Designed by cinema specialist William Riddle Glen, it brought the glamour of a transatlantic liner to Sunderland.

Unlike Black's Regal Cinema, the Ritz occupied a prominent corner site, allowing it to make a bold architectural statement. The façade is essentially a continuous curve that sweeps around the corner from Holmeside to Park Lane. The towering walls of brick are relieved by minute windows arranged in horizontal bands and the entrance was originally set below an abstract frontispiece of soaring vertical lines.

The foyer had the chic nautical styling of an ocean liner, with clean curves and metallic railings. During this era, luxurious liners such as the *Normandie* gave wealthy patrons access to exotic locations around the world. For those further down the social scale, cinemas were vessels of fantasy that provided a glimpse of distant worlds on the silver

Above: Figure 65. The Ritz Cinema on Holmeside. (Sunderland Antiquarian Society)

Below: Figure 66. The foyer had chic nautical styling. (Sunderland Antiquarian Society)

Figure 67. The auditorium was Sunderland's finest art deco interior. (Sunderland Antiquarian Society)

screen. The auditorium of the Ritz was the finest in Sunderland, with motifs of leaping gazelles and concentric arches to echo the proscenium.

Appropriately, the first film to be shown here was *Swing Time* (1936) starring Fred Astaire and Ginger Rogers. This was one of the great Hollywood musicals, produced by RKO studios and filmed on lavish art deco sets that complemented the prevailing trend in cinema design. The Ritz was eventually taken over by Associated British Cinemas and renamed the ABC in 1961. The building has since been converted into an entertainment complex called The Point and retains little of its original glamour due to extensive remodelling.

44. Joplings Store

The former Joplings department store on John Street was, for decades, a Sunderland institution. Along with Binns on Fawcett Street, it was one of the largest retailers in the North East and a major site of consumption. Built on the site of St Thomas' Church, the store is among the more interesting modern buildings in the town centre and a good example of post-war commercial architecture.

The firm of Joplings was founded in 1804 and operated as a draper's shop in High Street East. In 1882 the firm was bought by Stephen Swan and Robert Hedley, trading as Hedley, Swan & Co. but still known as Joplings. The company moved to premises on High Street West in 1919 and remained there until fire destroyed the store in 1954. The business moved into temporary premises until the present building opened in 1956.

Emerging in the early nineteenth century, department stores represented a revolution in retail, merging shopping with leisure. They were safe and respectable places for female consumers to browse and the use of clearly displayed prices took the anxiety out of the shopping experience, thus democratising consumerism. Their buildings were typically multi-storey structures on steel frames, which allowed the interior to be divided into specialist departments.

Joplings' new store was designed by Stanley Wayman Milburn (1888–1961), the son of William Milburn. It was constructed of brick and reinforced concrete using the principles of modernism, a radical European movement that transformed architecture in the twentieth century. Based on a rejection of past styles and a commitment to industrial materials, modernism was initially deemed too severe for conventional British tastes, but gained acceptance after the Second World War as an answer to post-war reconstruction.

The elevations of the Joplings store have a strong horizontal emphasis due to the use of strip windows and a sweeping concrete sill that was built to provide shelter for window shoppers. Display windows stocked with alluring goods were one of the sales tactics developed by sophisticated retailers. The upper storey is a glazed clerestory, with exposed structural supports in the form of modernistic flying buttresses. The long façades converge at the corner, where an abstract white plane rose up to display the name of the store and a clock face.

Figure 68. Joplings introduced Sunderland consumers to modern design.

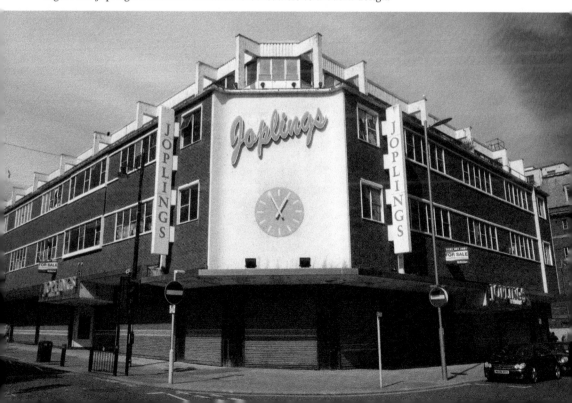

Figure 69. Advert for 1960s fashions at Joplings. (Sunderland Antiquarian Society)

Throughout the decades, Joplings gave Sunderland consumers access to ready-to-wear clothing and homeware, allowing local people to engage with the latest fashion trends and to furnish modern homes. Sadly, the store closed in 2010, but there are plans to convert it into a hotel.

45. Astral, Planet and Solar Houses

Towering above the city, Astral, Planet and Solar Houses are representative of the high-rise blocks built throughout Sunderland in the 1960s. In common with many other towns, Sunderland's post-war development was extensive, with more than 16,000 new council homes built in seventeen years. Blocks of flats and maisonettes were erected throughout the town according to the principles of European Modernism.

Much of the inspiration came from the Swiss-born architect and planner Le Corbusier (1887–1965), who used rationalist principles in utopian attempts to solve the world's housing needs. His *Unité d'habitation* in Marseilles (1947–52) exemplifies his dream of communal living. Each dwelling is a standardised unit within an epic superstructure of raw concrete. Le Corbusier's vision was implemented by British acolytes: similar designs sprang up across Britain as local authorities embraced industrialised building systems for home,

Above: Figure 70. Astral, Planet and Solar Houses exemplified the dream of modern living.

Right: Figure 71. The brutalist forms of Sunderland's 1960s shopping precinct. (Sunderland Antiquarian Society)

office and school construction. Each system used prefabrication to speed up construction while reducing reliance on expensive unionised labour.

Sunderland County Borough Council constructed three nineteen-storey tower blocks as part of the redevelopment of the town centre in 1967. The developers were Town & City Properties, who contributed £38,600 to the construction of the blocks. Llewelyn, Davies, Weeks and Partners were the architects and structural engineers for the towers. The firm was also responsible for the overall design of Washington New Town (1964). Ian Frazer and Associates were the architects for the sub-structural works and construction was carried out by Gilbert-Ash Northern Ltd, whose tender for the contract was £959,258.

The blocks contain 270 dwellings in total. The cellular design and astronomical names reflect the space-age concerns of the 1960s, a decade in which the superpowers were competing for supremacy in the cosmos and international prestige on Earth. The craze for all things futuristic pervaded architecture, design and popular culture.

New shopping units and elevated concrete walkways were built at the base of the three towers. The complex was an example of Brutalism, a notorious architectural style based on preformed concrete. Again, this was derived from the work of Le Corbusier, who, in his later years, began experimenting with a material he described as 'béton brut' or 'raw concrete'. The British architectural historian Reyner Banham (1922–88) adapted this term into 'brutalism' to define this harsh aesthetic of concrete masses and exaggerated monumentality.

Similar high-rise developments were built at Dame Dorothy Street (1962–64), Hedworth Court, Hendon (1963–64), Carley Hill Road, Southwick (1964–66), Walton Lane, Hendon (1964–67), Gilley Law (1964–68) and Abbs Street, Southwick (1966). In some cases, rows of traditional Sunderland cottages were demolished to make way for these utopian propositions for modern living.

46. Sunderland Civic Centre

Sunderland Civic Centre on Burdon Road (1968–70) is the administrative heart of the city, providing a base for Sunderland City Council. With its distinctive double-hexagon design, it is an important example of post-war British architecture and its council chamber has been witness to the decisions that have shaped Sunderland since the 1970s.

The extensive complex was built to replace Sunderland's Victorian town hall on Fawcett Street, which had become too small to fulfil its purpose. The demolition of the town hall in 1971 is Sunderland's greatest architectural tragedy and remains controversial to this day. In 1964, Sunderland County Borough chose the firm of Sir Basil Spence, Bonnington & Collins as architects for a new Civic Centre to be constructed on Building Hill. The principal partner, Basil Spence (1907–76), is best known for designing the modern cathedral at Coventry, after the medieval building was destroyed during the Blitz. However, Jack Bonnington was the lead architect for the Civic Centre scheme, which won an RIBA Gold Medal for the way it responds to the landscape. The Northern Architectural Association objected to building on this site, but building proceeded at a cost of £3,359,000.

The design consists of two hexagonal rings providing accommodation for administrative employees, connected by a four-storey core. Dendriform columns support the hexagonal blocks, the undersides of which reveal a concrete honeycomb structure. Internally, this

Above: Figure 72. Sunderland Civic Centre is formed of contiguous hexagons and follows the contours of Building Hill.

Right: Figure 73. The Council Chamber is lit by a hexagonal skylight. (Henk Snoek, RIBA Collections)

allows the non-loadbearing walls to be reconfigured if necessary. At the southern end of the site, a polygonal civic suite projects into the garden and a glass lift in the form of a prismatic tower is clasped to the perimeter. Located within the civic suite, the superb council chamber recalls the organic modernism of Eero Saarinen (1910–61). This geometric space is lined with brick and enclosed by a wooden ceiling with a dynamic skylight.

The building's profile has a strong horizontal emphasis, echoing the natural rock strata of Building Hill and giving it the character of a geological outcrop. By following the contours of the site, the centre responds to the topography in the manner advocated by Frank Lloyd Wright (1867–1959). A footbridge links the building to Mowbray Park and further integrates it with the landscape.

The centre is clad in brown engineering brick, which was installed in precast soldier courses (i.e. the bricks are laid vertically). Repeating hexagon motifs run from the floor tiles up to the superstructure itself, suggesting cellular growth or fractal geometry. The steps and access ramps form a cascade of planar facets, which has an impressive sculptural effect, but the monochromatic surfaces make them confusing and dangerous. The industrial brick finish continues inside to create synergy between interior and exterior.

Sunderland Civic Centre is unpopular with many residents due to its uncompromisingly modern design and the fact that it replaced the much-loved town hall. Technical flaws have become apparent over time, as is often the case with the industrial building systems that were once hailed as the last word in efficiency, but it remains a striking design.

47. Stadium of Light

The Stadium of Light (1995–97) was built as a state-of-the-art football ground to provide a permanent home for Sunderland Association Football Club. Built on the site of Wearmouth Colliery, it is the most potent symbol of Sunderland's post-industrial renaissance. It has the sixth-largest capacity of any English football stadium, with space for 49,000 spectators.

In hardworking industrial towns like Sunderland, spectator sports were an important form of recreation for workers and their families. For most of its history, Sunderland AFC was based at the much-loved Roker Park, which mainly consisted of standing terraces. Following the publication of the Taylor Report in 1990, the club was obliged to provide an all-seater stadium. The fact that Roker Park was enclosed by residential streets meant that expansion was impossible, so the club launched a plan to build a new stadium on the site of Wearmouth Colliery, which closed in 1993. Plans were provided by Miller Partnership and Taylor, Tulip and Hunter of Gateshead. Construction was carried out by Ballast Wiltshier at a cost of £15 million.

The stadium occupies one of the most spectacular settings of any football ground, raised on a promontory above the river and dominating views across the valley. Its resplendent white roof is suspended from an exposed structural frame. Walls of red brick give the building an organic quality and a sense of human scale. The perimeter walls incorporate a 'Wall of Fame' feature, allowing supporters to personalise the building by having their names engraved on the bricks. On the riverfront elevation is a projecting entrance block resembling a classical portico. The impressive Murray Gates display the club's emblem, while the stark piers are derived from classical forms and topped with paterae, a motif based on the bowls used in ancient ritual practices. These references metaphorically suggest

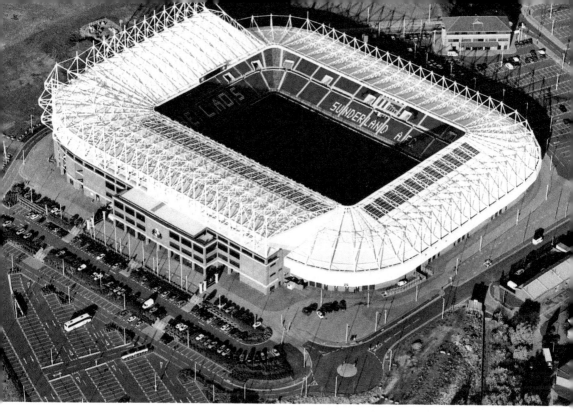

Above: Figure 74. The Stadium of Light commands a spectacular riverbank site. (Sir Bob Murray)

Below: Figure 75. The sunken pitch illuminated with floodlights. (Sunderland AFC)

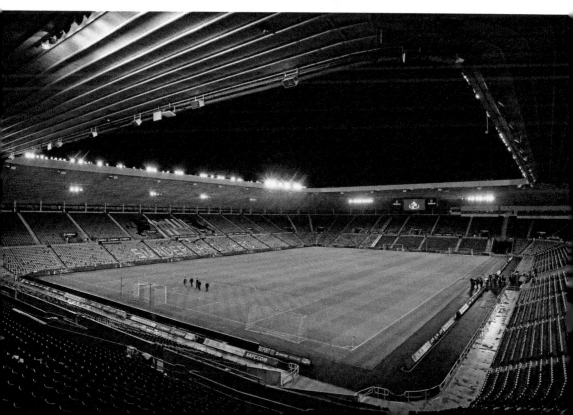

that spectator sport is a modern form of worship and remind us that football stadia trace their architectural lineage to Roman amphitheaters.

The stadium takes the form of a square arena, surrounded by four stands. The West Stand includes the Premier Concourse, which houses a number of executive boxes, while the North Stand features the Black Cats Bar. Football clubs generally have a strong sense of their own heritage and use this to inspire loyalty among their fans. Sunderland's emblem appears on the seats of the East Stand, while the North Stand features the colloquial slogan 'Ha'way The Lads'. The pitch is several metres below ground level and uses the Stadium Grow lighting system to ensure that grass can grow all year round. The ground was expanded in 2002 to seat 49,000, and its design allows for further expansion.

The stadium's unusual name was adopted, in the words of Sunderland's then-chairman Sir Bob Murray CBE, as 'an ever-lasting tribute to the region's mine-workers and proud industrial heritage and in the expectation that the stadium would be a guiding light in the future.'[54] Recognising the site's historic resonance, the club invoked Sunderland's heritage in order to embed the stadium within the local community. A monument by Jim Roberts of a miner's safety lamp stands in the grounds to reflect the coalmining industry that brought prosperity to the town. Curiously, this is not based on the world's first miners' safety lamp, developed in Sunderland by William Clanny, but on the more famous Davy Lamp. Nevertheless, the Stadium of Light has become a place of modern pilgrimage for its many followers.

48. National Glass Centre

The National Glass Centre is an educational and cultural institution on the north bank of the River Wear. Completed in 1998, it commemorates Sunderland's proud history of glassmaking and continues this industry into the twenty-first century. The centre contains a museum dedicated to the history of glassmaking and galleries for exhibitions. It also houses the University of Sunderland's Glass and Ceramics Department and Institute for International Research in Glass. The innovative building was a pioneering example of sustainable architecture.

In 1994, the Tyne & Wear Development Corporation held an open competition to design the centre and this was won by the architectural practice Gollifer Associates. Construction costs of £17 million were met by the Arts Council in conjunction with the University of Sunderland, Tyne & Wear Development Corporation, the European Regional Development Fund and Sunderland City Council.

The location was symbolic: the centre stands close to St Peter's Church, where Benedict Biscop introduced glassmaking to Britain and laid the foundation for Sunderland's own glass industry. Glassmaking flourished in the eighteenth century, driven by an abundance of cheap coal and high-quality imported sand. In more recent times, Pyrex glassware was manufactured in Sunderland, continuing this proud tradition.

The National Glass Centre has an industrial aesthetic, with much exposed steel and concrete. In this respect, it echoes the High Tech architecture of the 1970s and 1980s. Examples such as the Pompidou Centre in Paris (1971–77) emphasised their structural and functional elements by exposing them externally. Here, the image of heat exhausts and ventilation shafts evokes Sunderland's industrial heritage. The roof divides into two

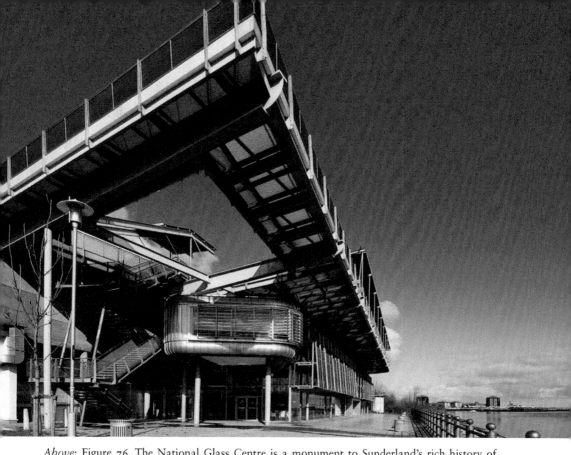

Above: Figure 76. The National Glass Centre is a monument to Sunderland's rich history of glassmaking (Keith Paisley).

Below: Figure 77. The restaurant and conference room exude a High Tech aesthetic.

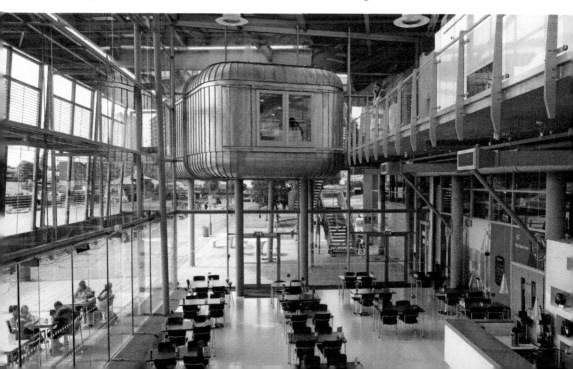

slopes, one ascending from ground level to form a veranda overlooking the river, the other plunging into the heart of the building to form the entrance. The roof is constructed of steel girders, which were meant to evoke Wearside's shipbuilding history.

As an institution dedicated to the production of glass, it is unsurprising that the building makes extensive use of glazing. Beneath the diagonal plane of the roof, glass curtain walls envelop the building. Most notably, the roof itself features large glass skylights that visitors can walk on and look down into the centre. The industrial aesthetic continues inside with a heavy-duty conference room that is supported on four steel legs filled with concrete.

The centre was among the earliest examples of green architecture in Sunderland; sustainability has since become an important issue within contemporary design. The building stood on derelict industrial land formerly occupied by J. L. Thompson & Sons' shipyard. The reclamation of the site took two years and involved removing concrete slipways and peaty material arising from wooden shipbuilding. To construct new foundations, the developers imported 200,000 cubic metres of crushed concrete from Wearmouth Colliery, where the Stadium of Light now stands. This not only recycled a waste product from the colliery, but also saved the need for new materials.

The Glass Centre is a model of efficient energy use. It uses the principle of bio-mimicry, which involves designing on biological lines and reusing energy in continuous closed cycles to reduce wastage. The building features a heat exchange system that uses heat from the glass furnaces to warm the building. To prevent overheating, an 'earth tube' sends air 3.5 metres below ground where the temperature is a constant 13 degrees Celsius, and uses it to cool the building. On initial estimates, this system saves £80,000 a year in fuel bills. An important example of culture-led regeneration, the building demonstrates how derelict industrial land can be transformed into progressive sites for the future.

49. Echo 24

Echo 24 on West Wear Street (2005–07) is one of the largest building projects undertaken in Sunderland since the millennium. Rising from a dramatic site on the south bank of the River Wear, this fifteen-storey apartment block is a sleek edifice with a mirrored façade and blade-like form. Visible for miles around, the building is a bold statement of Sunderland's ambitions as a twenty-first-century city.

The £38 million structure was built on the site of the *Sunderland Echo* newspaper offices, which closed in 1976. Sunderland's newest high-rise building, it contains a total of 179 flats over eleven floors. The iconic structure was designed by Mario Minchella Architects, whose lead partner is a member of the prominent Italian family that established an empire of ice cream outlets across South Tyneside in 1935. Craig Fitzakerly was the project architect. The developer was Glenrose of Jarrow. Tolent Construction acted as the main contractor, while Trent Concrete was the contractor for the façade. The steel framework was provided by Billington Structures.

The south elevation has an urban character, with stone cladding to reflect the grain of the streetscape and small FXi65 windows to reduce noise pollution, while the north elevation has a glass façade to capture spectacular views of the riverfront. Lightweight curtain walling was provided by Technal and the reflectivity of this façade was intended to integrate the building into its surroundings, linking land and sea.

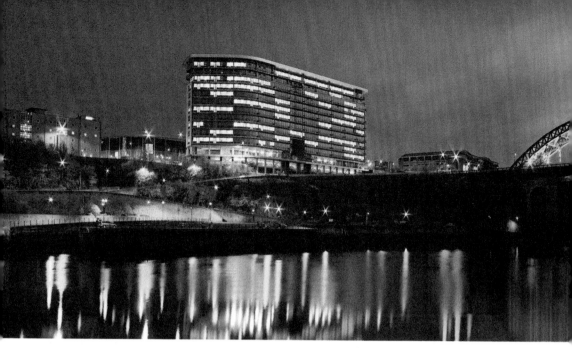

Figure 78. Echo 24 crystallises Sunderland's ambitions as the city of a new millennium. (Fitz Architects)

Spanning the glass wall are steel balconies reminiscent of boat decks, an allusion that has deep resonance in a former shipbuilding town. Ingeniously, the balconies were used when installing the glass panes, thus eliminating the need for scaffolding. The windows feature a tilt/turn mechanism for ease of cleaning by residents. The expansive façade is penetrated by a rectangular opening that frames the view of the river. Beneath the residential floors, the building includes commercial space and three levels of underground parking.

High-specification materials were used throughout. The structure is clad with 2,200 square metres of acid-etched white reconstructed stone. Because of the exposed location, all of Technal's systems were finished in marine grade silver polyester powder coating and glazed in Saint-Gobain green tinted solar control glass. Ceramic panels between the floor levels provide insulation and improve the building's thermal performance. The project won a Building Control Quality Award for Best Regeneration Project. With its streamlined form, Echo 24 has transformed Sunderland's riverfront and is a striking addition to the skyline.

50. CitySpace

CitySpace on Chester Road is a sports and social centre at the heart of the University of Sunderland's City Campus (2008–09). The landmark building is situated at an important gateway into the city and provides social, sports and events facilities within a distinctive envelope made of innovative materials. It was designed by the important North East practice of FaulknerBrowns Architects, who are responsible for many academic campus buildings, including the libraries of Durham and Newcastle universities. The structural engineer was Buro Happold and the main contractor Morgan Sindall.

This is a three-storey building with a strong horizontal emphasis. The broad elevation to Chester Road is a sheer white plane articulated with asymmetrical openings, some of which occur at the edges to disrupt the outline of the building. Filled with coloured glass, these openings create a vibrant, abstract design and animate the white façade, particularly when the building is illuminated at night. The main entrance is situated on the glazed end face, deeply recessed beneath a jutting canopy. According to Andrew Kane, a partner with FaulknerBrowns:

> The coloured glazing provides playful additions to the internal spaces during the day, and a colourful 'heart' after dark. The varied hues interact with the white concrete panels and give the building a unique identity.[55]

The pristine white forms recall the minimalist aesthetic of twentieth-century modernism, and like the best modernist buildings, CitySpace uses high-quality materials and shows great attention to detail. The façade is made up of high quality precast concrete cladding panels whose Spanish dolomite aggregate gives them a bright lustre, together with Bi-Modular cladding panels provided by ThyssenKrupp Building Systems. The glazing uses Technal's MX Grid system with low-profile framing set back in concrete cladding to make the windows appear frameless. The colour effects were achieved with Vanceva Polyvinyl Butyral interlayers in various shades of green.

Designed to be multifunctional, the centre has an in-built flexibility, providing a dining area, sports hall and a flexible events space called 'Citystudio'. The £12 million project was designed to a BREEAM 'Excellent' standard of environmental sustainability and won an RIBA award in 2010. As a focal point of the University of Sunderland's knowledge campus, the building develops the academic foundation laid by Benedict Biscop centuries before.

Figure 79. CitySpace enhances the urban campus of the University of Sunderland.

Notes

Introduction

1. *Lloyds Register of Shipping* quoted in Smith, J. W. and Holden, T. S. *Where Ships are Born: Sunderland, 1346–1946* (1946), p. 1.

The 50 Buildings

1. Giles, J. A. (ed.) *The Complete Works of Venerable Bede: Historical Tracts* (1843), p. 366.
2. *Sunderland Herald* (15 November 1867) p. 5, and 13 December 1867, p. 7; *Architect*, 13, 29 May 1875, p. 325.
3. Howitt, W. *Visits to Remarkable Places* (1842), p. 158.
4. Colvin, H. M., *A Biographical Dictionary of British Architects, 1600–1840* (1995), pp. 354–55.
5. Side galleries were added in 1842, but removed in 1935.
6. Anon., *Freemasons' Hall* (1985), p. 6.
7. Black, J., *Presbyterianism in Sunderland and the North* (1876), p. 10.
8. *Sunderland Herald*, 27 September 1834, p. 2.
9. Crosby, J. H., *Ignatius Bonomi of Durham: Architect* (1987).
10. *Sunderland Herald*, 25 January 1850.
11. *Northern Times*, 10 April 1840, p. 1; *Sunderland Herald*, 1 January 1841, p. 5.
12. Fordyce, W., *The History and Antiquities of the County Palatine of Durham*, 2 (1857), p. 522.
13. Pevsner, N. and Williamson, E., *The Buildings of England: County Durham* (2002), p. 468.
14. *Sunderland Herald*, 25 January 1850.
15. *Sunderland Daily Echo*, 20 December 1887, p. 3.
16. *Sunderland Herald*, 25 January 1850; *Building News*, 75, 16 December 1898, p. xiii.
17. *Sunderland Herald*, 25 January 1850.
18. *Sunderland Herald*, 25 January 1850.
19. *Sunderland Herald*, 25 January 1850.
20. *Sunderland Herald*, 8 May 1863, p. 5; *Building News*, 11, 5 February 1864, p. 105.
21. *Sunderland Daily Echo*, 1 September 1877, p. 2.
22. *Building News*, 17 September 1869, p. 221.
23. *Builder*, 29 April 1921, p. 544.
24. *Sunderland Post*, 20 December 1887, p. 3.
25. *Builder*, 37, 1879, p. 1379.
26. *Sunderland Daily Echo*, 20 April 1881 and 26 January 1883, p. 3; *Building News*, 45, 28 December 1883, p. 1043.

27. *Sunderland Daily Echo*, 28 May 1888, p. 4.
28. Eden, G. R. and MacDonald, F. C. (1932) *Lightfoot of Durham: Memories and Appreciations*, p. 89.
29. *Building News*, 21 February 1890, p. 270.
30. Milburn, G. E., *Church and Chapel* (1988), p. 48.
31. *Sunderland Daily Echo*, 8 February 1884, p. 3 and 6 February 1889, p. 3.
32. *Building News*, 3 October 1890, p. 489.
33. *Sunderland Daily Echo*, 24 September 1890, p. 2.
34. Sunderland Corporation, Deed Packet 61.
35. *Building News*, 73, 2 July 1897, p. 11; *Sunderland Daily Echo*, 27 September 1899, p. 3.
36. *Building News*, 79, 21 December 1900, p. 900.
37. Pearson, L. F., *The Northumbrian Pub* (1989).
38. *Builder*, 83, 13 September 1902, pp. 227–8.
39. *Sunderland Daily Echo*, 27 June 1907, p. 5; *Builder*, 93, July 1907, p. 88.
40. *Sunderland Daily Echo*, 8 August 1905, p. 5.
41. *Sunderland Year Book* (1907).
42. Goodhart-Rendel, H. S. 'Rogue Architects of the Victorian Era' in *RIBA Journal*, 56, 1953, pp. 251–9.
43. Marsh, D., *Description and Notes Concerning the Church of St Andrew's, Roker*, p. 27.
44. Prior quoted in Hawkes, D., 'St Andrew's, Roker' in *Architect's Journal*, 181 (5), 1985, p. 27.
45. Randal Wells quoted in Walker, L. B. (1978) *Edward Prior, 1852–1932*, p. 479.
46. Prior, E., 'Texture as a quality of art and a condition for architecture' in *Transactions of the National Association for the Advancement of Art and its Application to Industry* (London: Constabilitur Eundo, 1890), p. 322.
47. *Builder*, 93, 1907, pp. 385–6; *Sunderland Daily Echo*, 12 June 1906, p. 3; 13 June 1906, p. 3; 18 July 1907, p. 3.
48. *Northern Catholic Calendar* (1885).
49. *Sunderland Daily Echo*, 4 July 1906, p. 3.
50. Contemporary newspaper account, quoted in Crangle, L. P., *The Roman Catholic Community in Sunderland from the 16th Century* (1969), p. 74.
51. *Building News*, 98, 10 June 1910, pp. 794–5; Clayton Greene, C. A., *Churches and their Building* (1912).
52. *Architects' Journal*, 31 August 1932, pp. 245–249.
53. Sambrook, J. et al., *Puttin' on the Glitz: The Golden Years of Art Deco Architecture in Britain* (2012).
54. Official website of Sir Bob Murray.
55. Mara, F. 'CitySpace, University of Sunderland' in *Architects' Journal*, 28 September 2010.

Bibliography

Anderson, A., *The Dream Palaces of Sunderland* (Birmingham: Mercia Cinema Society, 1982).

Anon., *Freemasons' Hall* (Sunderland, 1985).

Black, J., *Presbyterianism in Sunderland and the North* (Sunderland, 1876).

Colvin, H. M., *A Biographical Dictionary of English Architects, 1660–1840* (London: John Murray, 1954).

Corfe, T., *Sunderland: A Short History* (Sunderland: Albion Press, 2003).

Crangle, L. P., *The Roman Catholic Community in Sunderland from the 16th Century* (Sunderland: Sunderland Antiquarian Society, 1969).

Crosby, J. H., *Ignatius Bonomi of Durham, Architect* (Durham: City of Durham Trust, 1987).

Eden, G. R. and MacDonald, F. C., *Lightfoot of Durham: Memories and Appreciations* (Cambridge: Cambridge University Press, 1932).

Faulkner, T. E., 'Robert James Johnson: Architect and Antiquary', *Durham University Journal*, 56 (1), January 1995, pp. 3–11.

Fordyce, W., *The History and Antiquities of the County Palatine of Durham* (Newcastle: Fullarton, 1857).

Garbutt, G., *A Historical and Descriptive View of the Parishes of Monkwearmouth and Bishopwearmouth and the Port and Borough of Sunderland* (Sunderland, 1819).

Garnham, T., 'Edward Prior: St Andrew's Church, Roker' in Dunlop, B. (ed.), *Arts and Crafts Masterpieces* (London: Phaidon, 1999).

Gettings, L., 'Benjamin Simpson, FRIBA' in *Northern Architect*, 12, 1977, pp. 28–31 and 13, 1977, pp. 33–8.

Giles, J. A. (ed.) *The Complete Works of Venerable Bede: Historical Tracts* (London: Whittaker, 1843).

Glendinning, M. and Muthesius, S., *Tower Block: Modern Public Housing in England, Scotland, Wales, and Northern Ireland* (New Haven: Yale University Press, 1994).

Greene, C. A. C., *Churches and their Building* (Sunderland, 1912).

Harper, R. H., *Victorian Architectural Competitions: An Index to British and Irish Architectural Competitions in The Builder, 1843–1900* (London: Mansell, 1983).

Hawkes, D., 'St Andrew's, Roker' in *Architect's Journal*, 181 (5), 1985.

Howitt, W., *Visits to Remarkable Places* (Philadelphia: Carey and Hart, 1842).

Johnson, R. J., 'St Peter's, Monkwearmouth', *Ecclesiologist*, vol. 27, 1866, pp. 361–4.

Milburn, G. E., *Church and Chapel in Sunderland, 1780–1914* (Sunderland: Sunderland Polytechnic, 1988).

Milburn, G. E. and Miller, S. T. (eds), *Sunderland: River, Town and People: A History from the 1780s* (Sunderland: Sunderland Borough Council, 1988).

Milburn, G. E., *St John's Ashbrooke: A Church and its Story, 1888–1988* (Sunderland: 1988).

Pearson, L. F., *The Northumbrian Pub: An Architectural History* (Morpeth: Sandhill Press, 1989).

Pevsner, N. and Williamson, E., *The Buildings of England: County Durham* (London: Yale University Press, 2002)

Potts, G. R., *A Biographical Dictionary of Sunderland Architects, 1800–1914* (2007).

Potts, G. R., 'Frank Caws: Sunderland Architect' in *Sunderland's History* (1998).

Prior, E., 'Texture as a quality of art and a condition for architecture' in *Transactions of the National Association for the Advancement of Art and its Application to Industry* (London: Constabilitur Eundo, 1890).

Sambrook, J. et al., *Puttin' on the Glitz: The Golden Years of Art Deco Architecture in Britain* (London: RIBA, 2012).

Smith, J. W. and Holden, T. S., *Where Ships are Born: Sunderland, 1346–1946* (Sunderland: Thomas Reed, 1946).

Stell, C., *An Inventory of Nonconformist Chapels and Meeting Houses in the North of England* (London: HMSO, 1994).

Surtees, R., *The History and Antiquities of the County Palatine of Durham* (Sunderland: Hills & Co., 1908).

Walker, L. B., *Edward Prior, 1852–1932* (unpublished PhD thesis: University of London, 1978).

Wickstead, J., *C. Hodgson Fowler; Durham Architect and his Churches* (Durham: DCLHS, 2001).